# The Louvre and the Ancient World

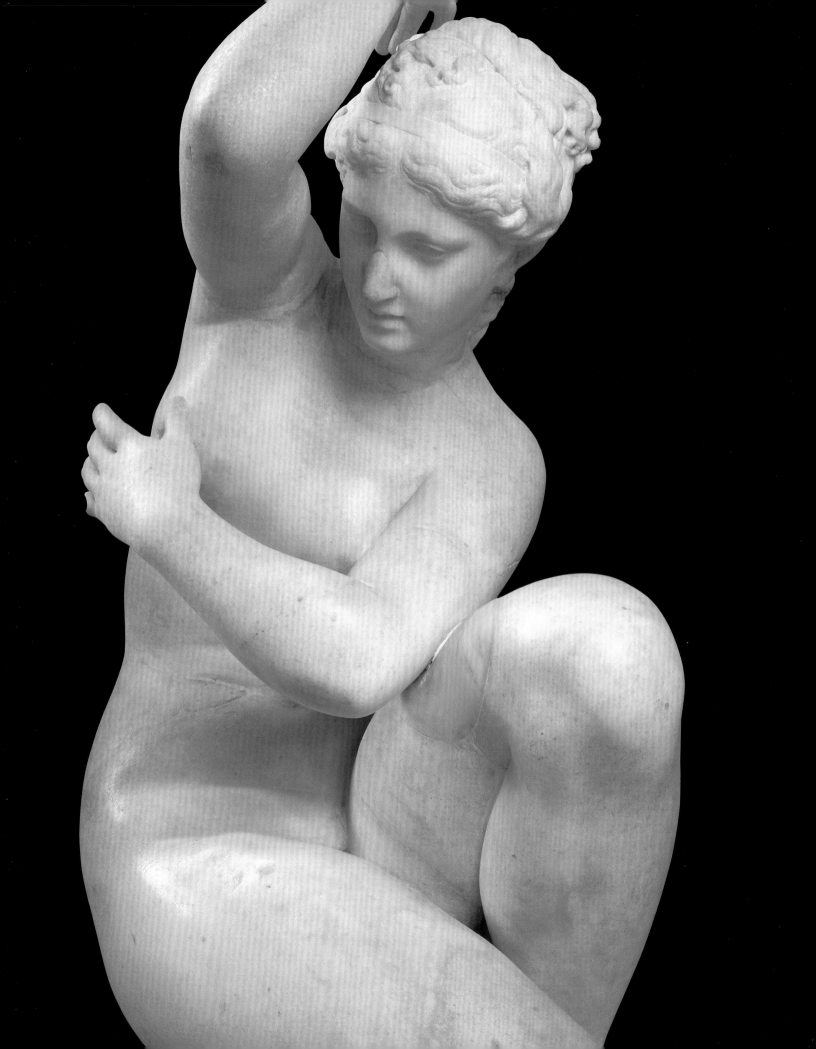

# The Louvre and the Ancient World

Greek, Etruscan, Roman, Egyptian, and Near Eastern
Antiquities from the Musée du Louvre

**LOUVRE** ATLANTA  A collaborative project of the Musée du Louvre, Paris,
and the High Museum of Art, Atlanta

# Contents

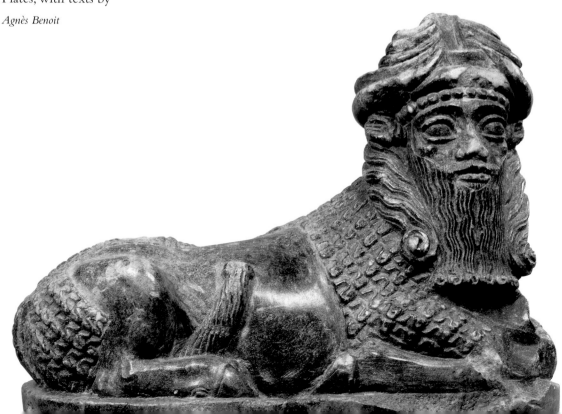

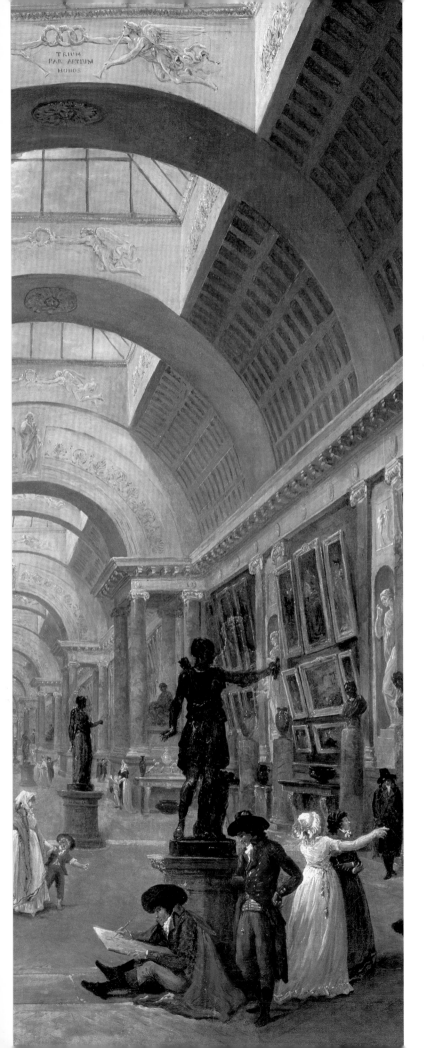

# The Louvre in the Nineteenth Century

# From the Musée Central des Arts to the Grand Louvre

*Geneviève Bresc-Bautier*

The monarchy had wanted to transform the Louvre Château into a palace-museum; with the Revolution this wish was fulfilled. On 10 August 1793, the Musée Central des Arts was opened to the Nation, who had become the owners of the building and the royal collections it contained. The Tuileries Palace, however, continued to be the center of political power, and within the Louvre artists and administrators shared those rooms not occupied by the museum. Henceforth, the history of the Louvre was to be inextricably linked with the new museum and its perpetual quest for additional space in which to place its continually expanding and ever-more varied collections. The Tuileries Palace remained the center of executive power, the seat of government and representation, until it was seriously damaged by fire in 1871 and finally demolished twelve years later.

*From the Directory to the Fall of the First Empire: A Museum of Conquests*

Once the tumult of the revolutionary period was over—a period during which the Assembly and different committees occupied the Louvre—the Directory and Consulate initiated a policy of extension and enrichment of the collections. At first, paintings took pride of place in the Museum, leaving the few sculptures, vases, and clocks possessed by the Louvre to make do with their secondary position on the long tables lining the walls of the Grande Galerie. A few antiquities and gold and silver pieces, selected from the property seized from the Church and French émigrés, found their way to the Museum, but it was mainly the conquests of the French Revolutionary armies in Europe that led to a massive transfer of a wide variety of artworks. Some works came as war booty; others were formally negotiated through agreements such as the Treaty of Tolentino with the Vatican and the Treaty of Campo Formio with Austria. While Napoleon was extending his quest to Germany and seizing many masterpieces from Berlin, Cassel, and Brunswick, the policy of transfer of major artworks from Italy continued to be strictly enforced. It is easy to oversimplify and condemn this policy of seizure and transfer of master-pieces to the French capital. At the time, it was viewed in different ways by different people. Certain members of the artistic and intellectual elite were delighted that so many paintings had at last left their somber churches and that so many statues had been rescued from the isolation of aristocratic collections; they saw the Museum as a forum of the Age of Enlightenment, a meeting place for international travelers. But other artists were bitterly opposed to the idea of so many works being taken from the environment where they had been produced, and they particularly criticized the policy of removals from Rome, the capital they so revered. The atti-tude adopted by this second group reveals perhaps the first awakenings of a national heritage awareness.

The Louvre Museum was enlarged to house the new treasures. The first Museum had been limited to the large square hall known as the Salon Carré and the admittedly very long Grande Galerie. Then in 1797 the first exhibition of drawings and decorative arts was held in the Apollo Gallery (fig. 1). In 1800 a number of ground-floor rooms were taken over to display the collections of antique sculptures; this "Musée des Antiques," with its entrance on the Place du Louvre, gradually extended north and south through the palace, taking over the summer apartments of Anne of Austria and the very first Gallery of Antiquities beneath the Salon Carré. The Musée des Antiques housed a collection of famous antiquities assembled from the Royal Collections, particularly those previously at Versailles, and from the masterpieces transferred from Italy, including statues from the Vatican, the Capitoline, and the Prince Albani collections in Rome and the *Venus de' Medici* from Florence. The star attractions were the famous statues of the *Laocoön* and the *Apollo* taken from the Belvedere Court in the Vatican (fig. 2). The transfer of the statues was supervised by the former curator of the Capitol Museum, Ennius Quirinus Visconti, a well-known connoisseur who now took up residence in Paris and began to work on the production of a scholarly catalogue for the museum. The architect Jean-Arnaud Raymond, who was appointed to design an appropriate setting for the masterpieces, brilliantly transformed the fresco-decorated rooms of the former apartment into a dazzling marble gallery. A group of painters and sculptors was appointed to decorate the Mars Rotunda entrance (fig. 3) and the first room, where the décor begun in the seventeenth century had never been completed.

When the Musée des Antiques opened, Napoleon Bonaparte (fig. 4) was still Consul—he was not to become Emperor until 1804. Dominique Vivant Denon, an engraver and a renowned writer, was appointed to direct the museum. He flattered Napoleon by suggesting that the museum be called the "Napoleon Museum" and initiated an ambitious policy of acquisition and presentation. Napoleon now became passionately interested in the Louvre; he agreed on a substantial budget, closely followed all projects, and had the final word on decisions. It was Napoleon who, realizing that the museum needed more space, decided to exclude from the Louvre not only the numerous studios and workshops occupied by artists, but also the body which had succeeded the former Academies, the Institut. It was also Napoleon who in 1811 decided to purchase the superb ensemble of antique statues owned by his brother-in-law, the Prince Borghese.

Napoleon worked simultaneously on a vast program of urban development in which the Louvre and the Tuileries were to be the key elements. Having proclaimed that "big is beautiful,"

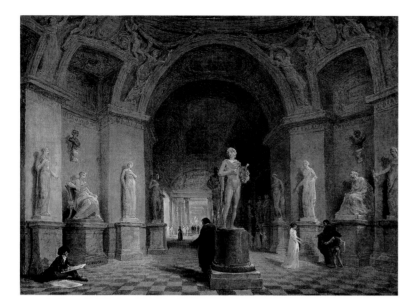

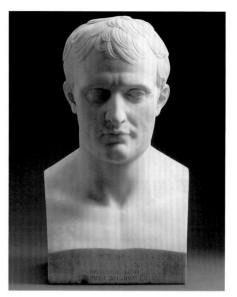

Fig. 3. Hubert Robert (1733–1808), *Project for the Installation of the Rotunda of Mars,* ca. 1797–1800, oil on canvas, 16⅛ × 21¼ inches, gift of Mr. and Mrs. D. David-Weill, 1948, Musée du Louvre, Department of Paintings, RF 1948–37.

Fig. 4. Antoine-Denis Chaudet (1763–1810), *Napoleon I,* before 1811, marble, 22 × 12⅝ × 11¹³/₁₆ inches, Musée du Louvre, Department of Sculptures, MI 40.

Fig. 5. Adolph and Emile Rouargue (active to 1871), *Place du Carrousel,* engraving, 4¹⁵/₁₆ × 5¾ inches, Musée du Louvre, Department of the History of the Louvre, G 413.

he turned his energies to the old royal project of linking the two palaces into one huge palatial complex. The architect Pierre-François-Léonard Fontaine was put in charge of transforming the Tuileries Palace, the official residence of the Consul and then of the Emperor, and of building new wings connecting it to the Louvre. Aided by his friend Charles Percier, Fontaine directed this major building operation until 1848, working on both the inside décor of the two châteaux and the construction of new buildings. To the north he designed the Rue de Rivoli, destined to become a major artery of Paris. He also started on the project of the north wing, planning to link the two palaces, and here he decided to work simultaneously from the two ends—from the Tuileries in the west and from the Louvre in the east. The two sections were planned to meet in the middle, but Fontaine did not live long enough to see the final accomplishment of the wing, which was only achieved during the Second Empire. He was responsible for the new grand entry to the Tuileries Palace, the Arc du Carrousel (fig. 5), built in honor of Napoleon's Grand Army. The architecture of the arch was based on the Septimus Severus Arch in Rome, but the architectural sculpture was designed by Denon (fig. 6). The upper parts of the façades of the Cour Carrée of the Louvre were unified, and the pediments and reliefs on the upper stories (which had been left unfinished) were sculpted, as was the Colonnade, the central part of the eastern façade. Napoleon's image was fixed on the edifice, but subsequently, under the Restoration, all references to the first emperor were removed. Inside the Louvre, Fontaine created two

grand staircases in the side pavilions flanking the Colonnade; this was where the Emperor cherished the hope of establishing his imperial apartments. Fontaine also worked on the museum itself. He did this in conjunction with Denon, even though the relationship between the two men suffered from hostility and rivalry. Fontaine transformed the Grande Galerie from a long, dark tunnel into the kind of gallery the painter Hubert Robert had

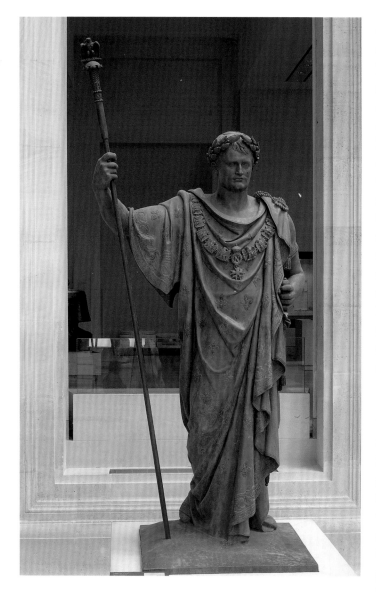

Fig. 6. François Frédéric Lemot (1772–1827), *Napoleon in Triumph,* 1808, lead, originally gilded, 126 inches high, Musée du Louvre, Department of Sculptures, MR 3458.

once dreamed of (fig. 7), the darkness henceforth banished by zenithal lighting and the long walls enlivened with Palladian bays. In the Musée des Antiques he continued work on the presentation of artworks, renovated the Salle des Caryatides, which dated from the Renaissance, and opened new galleries for the collection of Greek and Roman statues (fig. 8). Fontaine's very Neo-classical style, favoring the use of columns for interior architecture, can still be seen in the Salle des Colonnes, which today separates the New Kingdom Egyptian collections from the Greek terracotta collection in the south wing of the Cour Carrée. It can also be appreciated in what remains of the staircase that Fontaine built in 1809 to lead up to the rooms occupied by the museum, which now bear his name, the Percier and Fontaine rooms. The fall of the Empire in 1814 had few repercussions on the Louvre. But after Napoleon's return to Paris, the "Hundred Days," and the final defeat in 1815, the Allies decided that all those works of art which had been seized had to be returned to their respective countries of origin. Only a few isolated works that had been forgotten, conceded, or sold were not returned.

*The Museums of the Restoration: Opening to Distant Lands*
The three kings who succeeded to the throne between 1815 and 1848—Louis XVIII, Charles X, and Louis-Philippe—all resided in the Tuileries. During this period the museum continued to grow, but the tempo of the building program slowed down. Fontaine was only able to construct a small section of the north wing and organize the sculptural decoration of all the oculi windows in the Cour Carrée. With the arrival of new collections at the Louvre, however, he found ample scope to exercise his energies inside the building. For the Department of Antiquities he finished the reorganization and decoration of the ground-floor galleries of the Cour Carrée, now resplendent in red marble and ready to welcome the *Venus de Milo,* offered to Louis XVIII in 1821. On the upper floor he organized the Charles X Museum, which was inaugurated in 1827. It consisted of a luxurious suite of rooms with painted ceilings, including the *Apotheosis of Homer* ceiling by Jean-Dominique Ingres. Here a series of mahogany cabinets exhibited the collections of Greek and Roman vases and bronzes, decorative arts from the Middle Ages and the Renaissance, and those Egyptian monuments which were to leave such an indelible image, collected by the first Egyptologists, including the curator Jean-François Champollion (see page 50), the man who broke the secret of hieroglyphics. Simultaneously, nine other rooms were decorated with painted ceilings, re-organized, and finally inaugurated shortly after the opening of the Charles X Museum.

In another wing, a gallery was prepared for Renaissance and Modern sculptures and named the Angoulême Gallery (fig. 9), in honor of the heir to the throne. Elsewhere, a maritime museum called the "Musée Dauphin" was opened for the display of scale models of boats and exotic objects from the "South Seas" in the Pacific. In addition, an "American Museum" for pre-Columbian objects and an "Algiers Gallery," for the antiquities collected in Algeria during

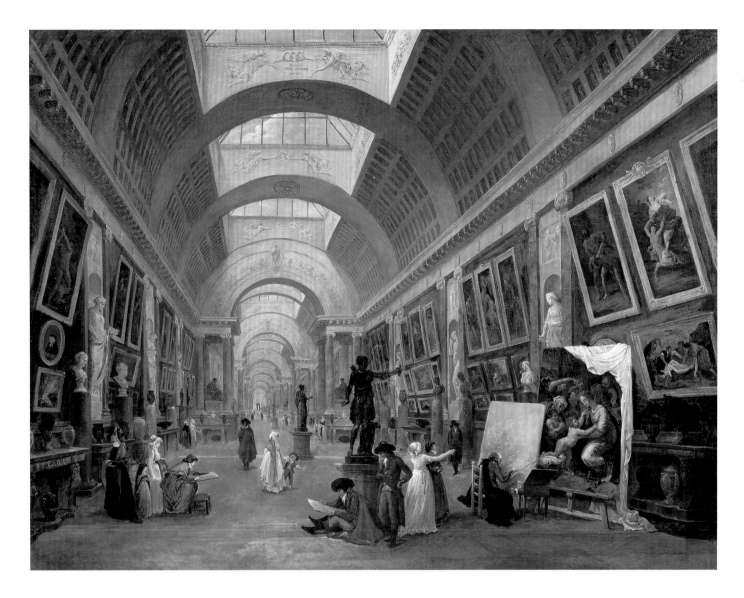

Fig. 7. Hubert Robert (1733–1808), *The Grand Gallery of the Louvre,* 1796, oil on canvas, 45¼ × 57 inches, Musée du Louvre, Department of Paintings, RF 1975–10.

Fig. 8. Attributed to Joseph Walencourt (1784?–after 1841), *View of the Ancient Room with the Tiber,* ca. 1824–1833, oil on canvas, 21⁵⁄₁₆ × 25⅝ inches, gift of Mrs. Alice Goldet, Musée du Louvre, Department of Paintings, RF 2003–07.

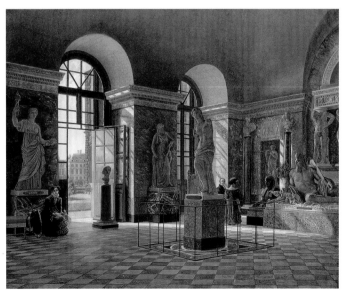

Fig. 9. Civeton and Hibon, *Musée royal des Antiques, Galerie d'Angoulême, Salle Germain Pilon,* engraving, in Comte de Clarac, *Musée de Sculpture antique et moderne,* 1826–1827, pl. 101, 8⅝ × 11 inches, Musée du Louvre, Department of the History of the Louvre, G 117A.

the reign of Louis-Philippe, were opened. This was also the period when the "Ancient Orient" took up residence in the Louvre: the Phoenician antiquities were the first to arrive, followed in 1847 by the Assyrian bulls from the Khorsabad palace of Sargon II (see page 80).

In spite of this proliferation of new galleries, the Louvre remained a royal palace. Fontaine prepared and furnished a State Hall, where meetings of the Assembly and the Senate directed by the king were to be held, and an apartment for the Conseil d'Etat (the State Council), provided with lavishly painted ceilings. These state halls were within the museum and can still be seen today in the Room of Antique Bronzes and the Department of Decorative Arts.

### From the Revolution of 1848 to the Fall of the Second Empire: The Vast "New Louvre"

The Revolution of 1848 presented the Louvre with the challenge of a major project, that of completing the linking of the Louvre and the Tuileries. In the Chamber of Deputies, Victor Hugo used his passionate rhetoric in defense of this project, which he referred to as a "Mecca of Intelligence" (for the Bibliothèque Nationale was to be included within the museum). Following a Keynesian policy, the government eagerly sought to give new impetus to the economy and combat unemployment by creating "national workshops" and instituting a building program. An enormous budget was voted. The architect Félix Duban, who had succeeded Fontaine, directed the work of renovating and creating vast new galleries. He restored the façades of the Grande Galerie and the Petite Galerie. He added new splendor to the Apollo Gallery, which had been begun under Louis XIV but never finished: Le Brun's paintings and stuccoes were restored, and new paintings were commissioned from contemporary artists, including Eugène Delacroix, who painted the gigantic *Apollo Vanquishing the Serpent Python* in the center of the vault (fig. 10). At the same time, Duban ordered the redecoration of the Salon Carré, that sanctuary for masterpieces of all times and from all countries, and organized a second "Salon," this time for French painting, the Salle des Sept Cheminées.

During the same period, another architect, Louis-Tullius Visconti, the son of the former curator of antiquities, was entrusted with overseeing the project of joining the Louvre with the Tuileries. He planned to conceal the difference in appearance between the wings by constructing new buildings around inner courtyards. But his project was never completed; only the first stage was achieved, that of clearing the area between the two palaces of all the houses and other buildings which had grown up over the centuries. Then a series of events radically changed the political situation. The coup d'etat of 2 December 1851 brought Louis-Napoléon Bonaparte to power, first as Prince-President, then the following year as Emperor. He willingly continued with the projects of the Republic, for they had been initiated by his uncle, Napoleon I. After consolidating his personal reign, he ordered Visconti to continue with his project but with modifications; instead of placing the national library in the museum, the emperor expressed his preference for an "imperial city," with ministries, administrative headquarters, barracks, and stables. He now resided in the Tuileries and took a fervent personal interest in the project and agreed to a huge budget for the works. On 29 February 1852, Visconti presented his project (fig. 11) at an estimated cost of twenty-five million francs. The project was accepted by decree on 12 March.

The gigantic building projects, employing more than three thousand workmen, continued day and night for nearly five years. The running of the project was assured by an architectural agency, directed by Visconti until he died very suddenly on 29 December 1853 and subsequently

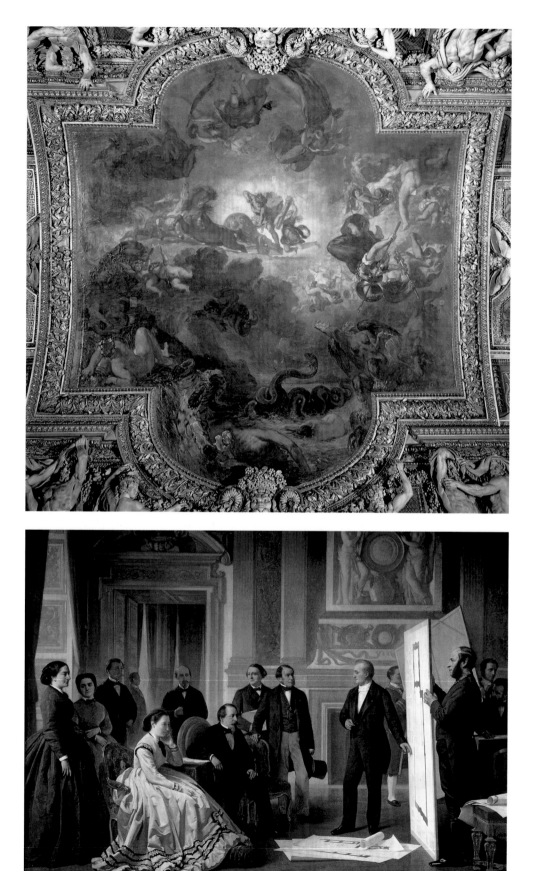

Fig. 10. Eugène Delacroix (1798–1863), *Apollo Vanquishing the Serpent Python,* ceiling of the Apollo Gallery, 1850–1851, oil on canvas, 26³⁄₁₆ × 24⅜ feet, Musée du Louvre, Department of Paintings, INV 3818.

Fig. 11. Tissier Ange (1814–1876), *Visconti presenting the plan for the new Louvre to Napoleon III,* 1865, oil on canvas, 70 × 91 inches, Musée du Louvre, Department of Paintings, DL 1989–1; MV 5435.

by Hector-Martin Lefuel. The latter modified Visconti's plans when he decided to heighten the buildings and provide a more exuberant sculptural decoration for the façades.

The building progressed rapidly. In 1854, the section of the north wing that abutted the Carrousel and the Rohan pavilion was built as a junction between the two sections of the wing constructed during the Napoleonic and Restoration periods. At the same time new buildings appeared around the vast new square first called Cour Louis-Napoléon, then Cour Napoléon. This was achieved by means of simpler, longer wings, punctuated in the center by the important Pavillon de la Bibliothèque (the Library Pavilion) opposite the Palais Royal (fig. 12). These new buildings were provided with inner courtyards offering space and light. Although the Museum acquired some new galleries to the south, much space was reserved for the needs of the Emperor and his government, including a big Manège (ring for training horses) and a vast State Hall for meetings—the second Salle des Etats. The buildings in the north were used for more practical purposes; they housed the barracks, the ministry responsible for the Louvre building works, the ministry for the Arts, and the Imperial Library. Lefuel displayed his genius for stagecraft when designing the vast staircases built to reach the upper floors. In the north, the wings and pavilions of the palace were named after the great ministers of the Ancien Régime—Richelieu, Colbert, and Turgot—and in the south after those who had served the First Empire—Daru, Mollien, and Denon. In 1856 it was decided to harmonize the old east façade with the new constructions and to conceal the austere building of the sixteenth and seventeenth centuries with a very ornate sculptured facing. The old central pavilion, known as the Pavillon de l'Horloge, was renamed Pavillon Sully, in honor of the last Bourbon minister, although it continued to bear the bust of Napoleon I on its pediment.

As Lefuel had decreed, the sculptural decoration was ornate and lavish yet, like the building itself, very much inspired by the sculpture on the sixteenth- and seventeenth-century palace. It was completed in the record time of four years by the most important sculptors of the period: Barye, Carpeaux, Duret, Guillaume, Préault, Rude, and Simart. A gallery ran along the ground floor, topped by a terrace decorated with gigantic statues (more than three meters high) of great political, artistic, and literary figures of the past, while the attic story was occupied by allegorical

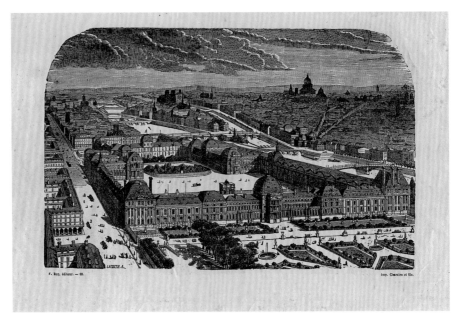

Fig. 12. Lacoste, *View of the Connection of the Louvre and the Tuileries,* before 1861, engraving, 5½ × 8⅜ inches.

Fig. 13. Jean-Baptiste Carpeaux (1827–1875), *Flora,* 1873, terra-cotta relief, 54⅛ × 31³⁄₁₆ inches, Musée du Louvre, Department of Sculptures, RF 1543.

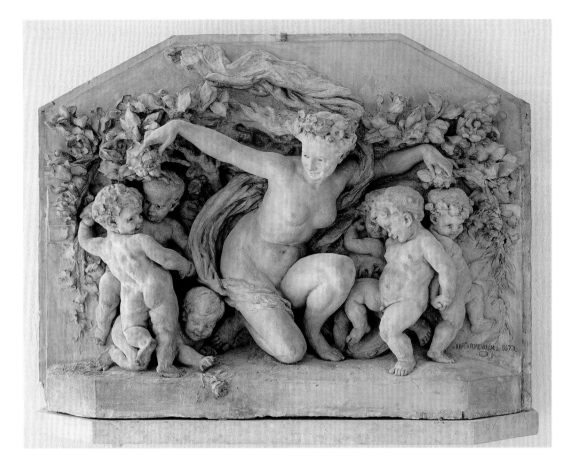

groups of *genii.* The pediments of the central Richelieu and Denon pavilions presented the Emperor in his role of harbinger of peace and prosperity. Other allegories glorifying the virtues of imperial government stood out from beside the oculi windows and crowned the Turgot and Mollien corner pavilions and the intermediary pavilions.

When the building was inaugurated in August 1857, the interior décor had not yet been completed, and work on it continued throughout the Empire. Meanwhile, Lefuel began a new campaign of destruction and reconstruction in the south, mainly in the Tuileries and the Grande Galerie. Beginning in 1861, the Flore Pavilion was destroyed, rebuilt, and decorated with sculptures by Carpeaux (fig. 13). A large section of the Grande Galerie was demolished, and a new pavilion was built to house a third State Hall, which was named the Pavillon des Sessions (the Meetings Pavilion). On the east side, the triple-arched opening of the Grands Guichets was built as a first step in the construction of the capital's new north-south artery. In fact, this artery, which was planned to begin at the new Opera building, was never created. The fall of the Empire in 1870 and the Tuileries fire of 1871 put an end to all dreams of a great imperial city. The junction of the two palaces had only lasted a bare fourteen years; the government left the Louvre, and the museum began its long process of final conquest, which it only accomplished at last in 1993. Henceforth, it was no longer the Tuileries but the Louvre which stood at the head of the great east-west artery, stretching out across the Place de la Concorde and up the Champs-Elysées to the Arc de Triomphe at the Place de l'Etoile.

While all this building was going on, the museum continued to expand. New scientific museums, including an ethnographic museum linked to the maritime museum and a Chinese

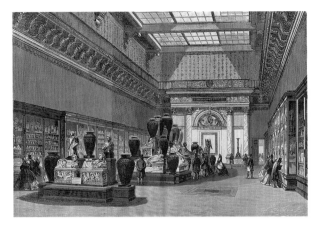

Fig. 14. Michel-Charles Fichot (1817–1903), *The new rooms of the Musée du Louvre—the Terra-cotta room, Campana Collection,* after 1868, in *Paris Nouveau illustré,* no. 15, p. 232, engraving, 3½ × 4¹³⁄₁₆ inches.

Museum, had already appeared during the Republic, and the number was to increase during the Empire. In the old part of the Louvre, spacious rooms were reserved for the big Egyptian monuments and the winged bulls of Sargon's palace at Khorsabad. When the Emperor acquired the important Campana collection from the bankrupt Marquis Campana (the former director of the Monte di Pietà, or loan bank, in Rome), it became the nucleus of his "Musée Napoléon III," alongside objects discovered during excavations he had ordered. A prestigious collection of Etruscan artworks, Greek vases, fourteenth- and fifteenth-century Italian paintings, Della Robbia glazed terracottas, and majolicas thus entered the Louvre. Part of this ensemble was placed in the Renaissance Museum on the upper floor, while another was displayed in the recently renovated first State Hall in the Cour Carrée of the old Louvre. Yet another part was exhibited in a gallery known henceforth as the Campana Gallery (fig. 14), which ran alongside the gallery containing the Charles X Museum. The Emperor also wished to have a "Musée des Souverains," dedicated to the royal dynasties that had ruled France—the Bourbons, and also, of course, the Bonapartes. The most beautiful rooms of the Colonnade wing, today devoted to the Egyptian collections, were reserved for this Musée des Souverains. The new buildings also provided additional space for the museum's collections: spacious rooms upstairs for large paintings, big galleries on the ground floor, and the more intimate Salle des Sept Mètres for the Italian schools of painting. These rooms were all adorned with decorative paintings and sculpture, but a particularly spectacular and lavish décor was reserved for the Salle des Empereurs. This gallery, planned to house the collections of antique sculpture, was given a huge ceiling decorated with paintings and stuccoes on historical themes. Thus the hall, which dated from the reign of Henry IV, was given a new look with a décor celebrating past and present emperors, including Augustus and Charlemagne but also Napoleon I.

The most luxurious décor was reserved for those parts of the Louvre used by the Emperor and his imperial government: the Ministry of State in the sumptuous apartments of Napoleon III, the Salle du Manège, the second State Hall and the room preceding it (known as the Salon Denon), and the staircase leading to the Salon Denon, the Mollien Staircase. Both the iconography and the eclectic style referred to previous reigns, particularly that of Louis XIV. This political and artistic historicism, which had excellent if somewhat conventional results, was implemented by artists who displayed a remarkable savoir faire, who worked at great speed, and who showed great skill in adapting their work to the building they were working on.

## The Expansion of the Museum under the Third Republic

With the New Louvre of Napoleon III, the expansion came to an end. In theory, the burning of the Tuileries by the Paris Commune in May 1871 and the destruction of the Tuileries Palace for political reasons in 1882 meant that the museum authorities now became the masters of the Louvre, since the President of the Republic moved from the Louvre and set up his headquarters in the Elysée Palace. But it was not quite that straightforward. The headquarters of the Ministry of Finance were burned during the fire of 1871 and, along with other institutions, the Ministry set up office in the north wing and part of the south wing of the Louvre. Their departure from the Louvre took many, many years and was only finally concluded in 1989. But it was a necessary departure, one that released vital space for the ever-expanding collections.

Although the Louvre collections were somewhat reduced when the small pre-Columbian and ethnographic collections left the building in 1874 to be re-housed in a new ethnographic museum, expansion was considerable in all other areas. The Louvre did not benefit from the very large budgets enjoyed by the museums of Berlin and London, but donors were particularly generous and left whole collections of the greatest quality to the French museum.

Moreover, although the works of living artists were exhibited at the Luxembourg Museum, the Louvre regularly received the works of artists after their deaths, transforming the Louvre into a museum of modern art. This great influx of collections provoked an increase in the amount of space occupied by the museum, which now took over the second State Hall, then the upper levels of the Cour Carrée, and gradually the Flore wing.

By 1900 the Louvre had become a universal museum, with East and West rubbing shoulders. Visitors were numerous, entry was free, and the Louvre was an international success. But there were also problems. The lack of space meant that works of art were crowded together and there was no real logic to the circuit through the museum. Individual collections were allocated their own placements with little thought given to the connection between them. A separate room or gallery had to be given to every collector who donated his collection; this tradition had begun in 1856 during the Empire, with the Sauvageot donation. In 1864 it was La Caze, the philanthropist, the "doctor of the poor," who donated his collection, consisting of hundreds of paintings, including Watteau's *Pierrot*. The La Caze collection was honored by being placed in the old meeting room which had become the Musée Napoléon III. Then there were the rooms devoted to the collections donated by Camondo, Schlichting, the Marquess Arconati-Visconti, Moreau-Nélaton, the Rothschilds, and Grandidier. The Louvre would not be what it is today were it not for the generosity of these great donors.

It was not until the twentieth century that this multitude of collections was rationalized. A reorganization plan was initiated in 1926 and continued to be implemented, in spite of the war gap, until the Grand Louvre Project was launched in 1981. The vast Grand Louvre Project is still in operation today. The old palace has been completely restored and transformed, and the I. M. Pei pyramid has given it a new lease on life. The 1926 plan stipulated that certain collections, which had contributed to making the Louvre a "universal museum" during the nineteenth century, should leave the Louvre premises. Consequently, the Far East is now represented at the Musée Guimet, a museum devoted to Asian arts; the Marine Museum has moved to Chaillot; and the paintings of the Impressionists are now in the Musée d'Orsay (since 1986), after a spell at the Musée du Jeu de Paume. The absolutely phenomenal expansion in the number and quality of the collections has rendered inevitable the creation of other museums limited to certain geographical areas or chronological periods.

The universal museum of the nineteenth century is no longer. The Louvre of the twentieth century, consisting of eight major departments, is constrained by the chronological boundary of 1848 and limited to certain areas. But much of its strength and its force comes from those long years of growth, when a certain conception of art was fashioned and created for so many artists. For, let us never forget, it was during the nineteenth century that the Louvre played the vital role of providing artists from all over the world with models they could follow and learn from, and offered them a forum where they could develop the cultural heritage they would leave to posterity.

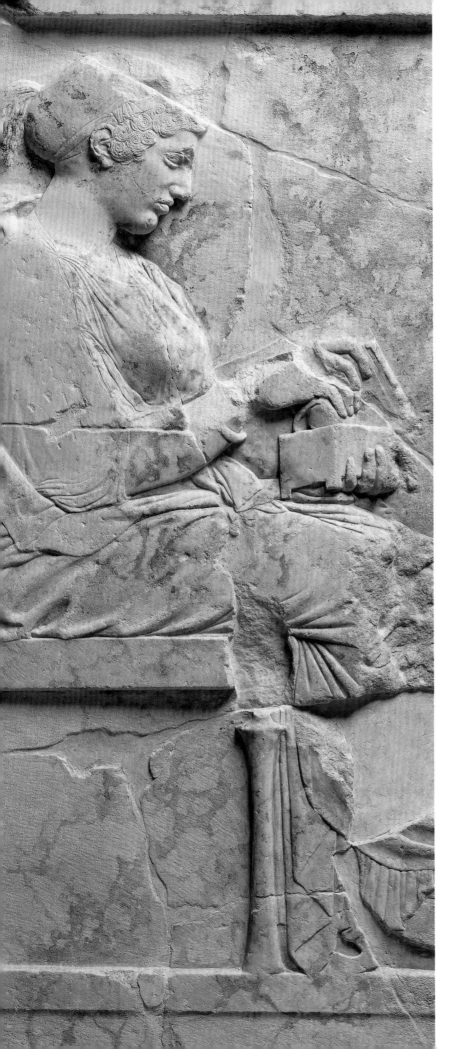

# The Classical Past

# Greek, Etruscan, and Roman Antiquities

*Alain Pasquier*

The Department of Greek, Etruscan, and Roman Antiquities, together with the Department of Paintings, is the oldest of the Musée du Louvre. In addition, it occupies those galleries and rooms of the Palace which most echo with the history of France: not only the Salle des Caryatides (fig. 1), the very heart of the royal residence built by François I to replace Philippe-Auguste's austere fortified castle, but also the apartments once lived in by the kings and queens of France.

Today the Department occupies three levels of the museum. Although the principal goal is to present the public with major works of art, more modest objects representative of the history of the Greek, Etruscan, and Roman civilizations are also sometimes displayed. Great masterpieces such as the *Victory of Samothrace* (fig. 14) are thus to be found alongside clay lamps and other simple objects. The grouping together of the three classical cultures is the result of a deliberate choice, based on the common characteristics of the three cultures and the awareness that together they form the basis on which our Western civilization is founded.

The Department houses works created from a wide range of materials. In addition to marble—the most commonly used medium for statuary—many objects are of bronze and clay. Others are crafted from precious materials—gold, silver, and ivory. Wooden artifacts, which were

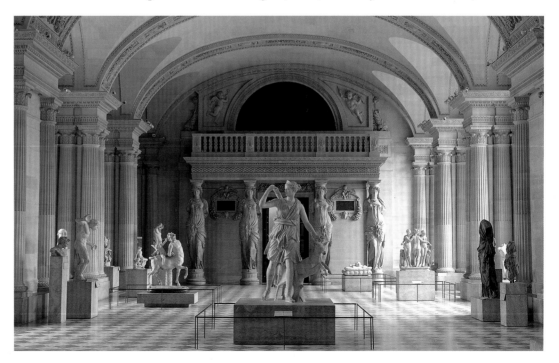

Fig. 1. View of the Salle des Caryatides with the *Diane of Versailles* in the middle, after an original bronze created by Leochares in 330 BC, Musée du Louvre, Department of Greek, Etruscan, and Roman Antiquities.

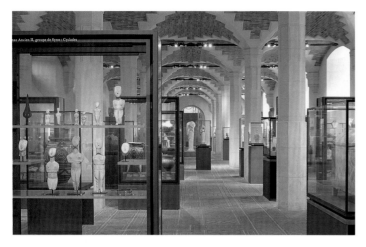

Fig. 2. Collection of Cycladic figurines from the entrance of the Gallery of Pre-Classical Greece, Musée du Louvre.

Fig. 3. Kore dedicated by Cheramyes, Greek, Sanctuary of Hera, Samos, 560 BC, marble, 75⅝ inches high, Musée du Louvre, Department of Greek, Etruscan, and Roman Antiquities, Ma 686.

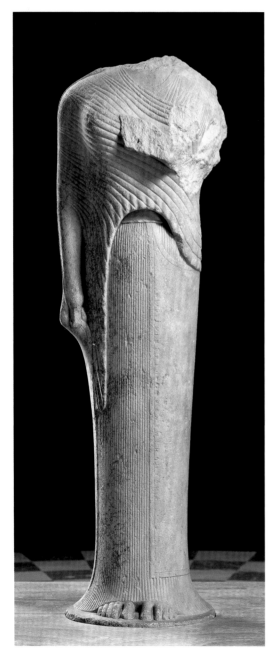

not conserved as in Egypt by a favorable climate, are rare, but glass, stucco, and amber works have their place, as do paintings and especially mosaics. This abundance of different materials results in a striking variety of forms, dating from the end of the fourth millennium BC up to the fifth and sixth centuries AD, and illustrating nearly 4,000 years of history in the vast area of the Mediterranean basin.

Since the Louvre museum first opened, the methods adopted by the Department to present its collections have varied, dictated sometimes by a common iconography, at others by a similar provenance. However, one principle governing presentation methodology, which was initiated at an early stage, has never been abandoned. This is the principle advocating an approach based on chronology and favoring an understanding of how events and phenomena evolve and succeed one another. Such an approach also implied that objects from each of the three civilizations be displayed in separate rooms. The Department implements the chronological approach in two ways. In the lower-level galleries and rooms, different kinds of objects made from a wide variety of techniques are presented together, so as to provide as complete a picture as possible of the art production of a particular period. In contrast, the rooms on the first floor are designed to group together the same types of objects so that the evolution of different techniques—painted vases, for example, or terracotta and bronze statuettes—can be more clearly understood. The case of marble statues is more complex; many Roman marble statues reproduce Greek models in bronze that have disappeared. The Department has chosen to distinguish between its few Greek originals on the one hand and on the other its collection of Roman copies, often the only evidence we have today of Classical Greek and Hellenistic statuary. There is thus a clear division between those rooms displaying original works, whether in marble or other materials, and those containing Roman statues organized according to their period of production.

When arriving at the Department from the lower-level Pyramid entrance, the visitor enters the first gallery, which contains the most ancient objects. These include works from the Cycladic civilization (fig. 2), followed by the few objects which the Louvre possesses from Minoan Crete, and finally those works produced by the Mycenaeans, the first Greeks to occupy the Balkan peninsula that would one day be called Greece. The same gallery presents masterpieces from the Archaic period, including big statues (fig. 3), figured vases, and small figures in bronze and terracotta. At the end of the gallery, the visitor mounts a staircase and comes to the area displaying the marble fragments from the Temple of Zeus at Olympia (fig. 4), one of the first examples of Greek Classicism. The other rooms on the ground floor normally devoted to Greek art are at present being

renovated, but will soon house works predominantly in marble from the fifth and sixth centuries BC—in particular, fragments of architectural sculpture from the Parthenon (fig. 5), bronze and terracotta objects, and Roman marble copies of Greek originals. Finally, the Salle des Caryatides contains Roman copies or adaptations of Greek sculpture from the Hellenistic period.

In the Etruscan rooms on the same level, the visitor can observe and enjoy this very original art—which began by borrowing much from Greece and then toward the end of its history fused increasingly with Roman art. The connection between Etruscan art and the two other classical civilizations has unfortunately led to the former being considered and treated in many museums as a kind of by-product, whereas in fact the Etruscans produced works of art in stone, bronze, and terracotta that bear the stamp of their own special genius.

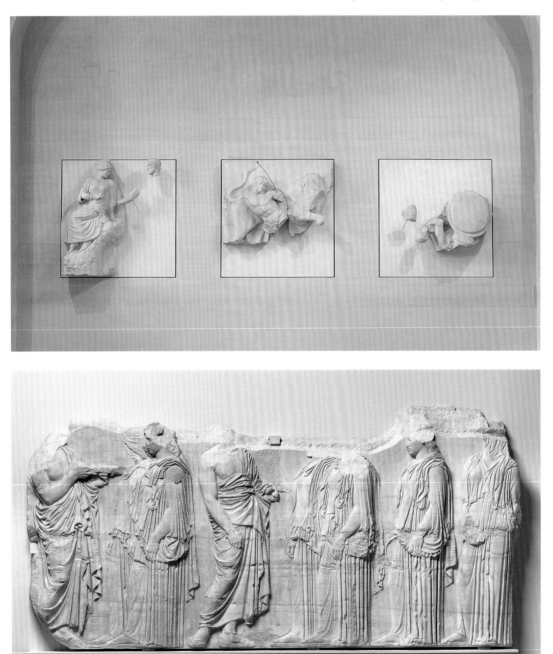

Fig. 4. Marbles from the Temple of Zeus at Olympia, Musée du Louvre, Department of Greek, Etruscan, and Roman Antiquities.

Fig. 5. Fragment of the frieze of the Parthenon, Greek, Athens, ca. 445–438 BC, Pentelic marble, 37¹³⁄₁₆ × 81½ inches, Musée du Louvre, Department of Greek, Etruscan, and Roman Antiquities, Ma 738.

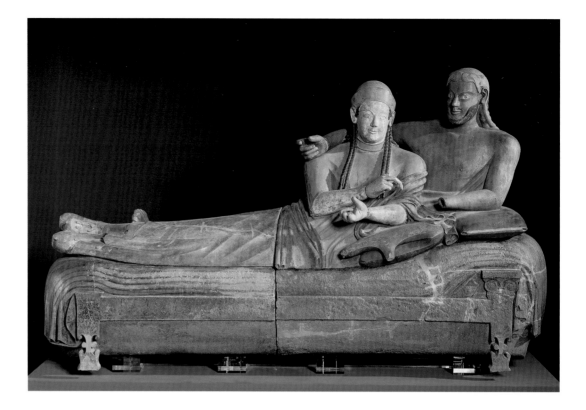

The superb *Sarcophagus of the Spouses* (fig. 6) and the Louvre's collection of gold and bronze jewelry bear witness to a brilliant civilization which still guards many of its secrets. Today, because of lack of space, it is not possible to display the many different aspects of Etruscan art which the rich collection of the Louvre could provide, especially if one includes those works produced in Italy for certain pre-Roman civilizations.

The Roman rooms are also organized chronologically and follow Roman history from the Republic to the last days of the Empire. In addition to the numerous reliefs and sculpted sarcophagi, there is a magnificent collection of portraits—perhaps the area in which the Romans most excelled—executed by artists who brought to perfection the art of revealing the inner feelings of an individual on his or her face (fig. 7). The Louvre also has a fine collection of mosaics, including the flooring from the Paleo-Christian church of Qabr Hiram, which will soon be placed in the center of other works from the vast eastern, Hellenized part of the Roman Empire.

The collections on the first floor are ordered both chronologically and according to the material in which they are crafted. A first room containing a rich collection of statuettes (fig. 8), vases, and different utensils, all in bronze and dating from the Greek Archaic to the late Roman period, leads into a second room, where a display of bronze furniture and silverware evokes the splendid Roman residences these objects once decorated. Popular beliefs are evoked in a more modest fashion via the multitude of terracotta statuettes, and funerary and votive offerings on display in the succession of rooms that constitute the Charles X Gallery (fig. 9). Finally, the Campana Gallery (fig. 10) offers its superb collection of Greek and Italiote vases, centered around the essential collection built up by the Marquis de Campana and classified according to the workshops or even to the actual painters responsible for their production.

The Department's collections were composed around a precious nucleus—the collections assembled not only by those great French statesmen Richelieu and Mazarin, but also by the kings of France themselves. In following such a policy, the monarchy and its brilliant ministers were emulating the great families of Italy, who, from the beginning of the Renaissance, amassed

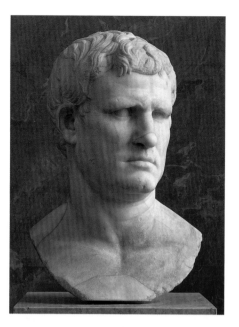

Fig. 7. *Portrait of Marcus Agrippa,* Roman, 25–24 AD, marble, 18⅛ inches high, Musée du Louvre, Department of Greek, Etruscan, and Roman Antiquities, Ma 1208.

Fig. 8. Salle des Bronzes, Musée du Louvre, Department of Greek, Etruscan, and Roman Antiquities.

Fig. 9. Charles X Gallery with sculptures of heroes and divinities, Greek and Roman, Hellenistic and Roman eras, Musée du Louvre, Department of Greek, Etruscan, and Roman Antiquities.

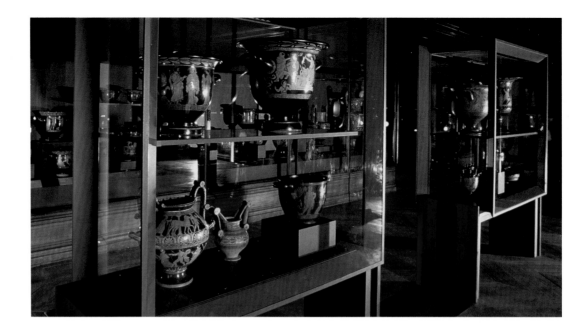

the vestiges of an Antiquity they revered and admired, antiquities discovered in different parts of the Italian peninsula, but especially in Rome. The act of collecting antiquities enabled them to reveal their open, receptive attitude toward the most refined of civilizations, and also to exhibit their own opulence and power. The arrangement of the Salle du Manège (fig. 11) is designed to reflect this phenomenon. It is important to note that a substantial part of the Italian collections arrived at the Louvre in a variety of ways: some came in the wake of conquest, following the victories of first the French Revolutionary armies and then the imperial military campaigns, while others were the object of proper negotiation and due payment. Whereas the marble statues of the Albani family were taken by force, the Borghese Collection was bought at a high price from Napoleon's brother-in-law, Prince Camille. Together the two collections constitute by far the major part of the antique statuary conserved at the Louvre, sculptures which at the beginning of the museum's history constituted the lion's share of the department's collection.

Fig. 10. Campana Gallery featuring Greek and Italiote vases, Musée du Louvre, Department of Greek, Etruscan, and Roman Antiquities.

Fig. 11. Salle du Manège, Musée du Louvre, Department of Greek, Etruscan, and Roman Antiquities.

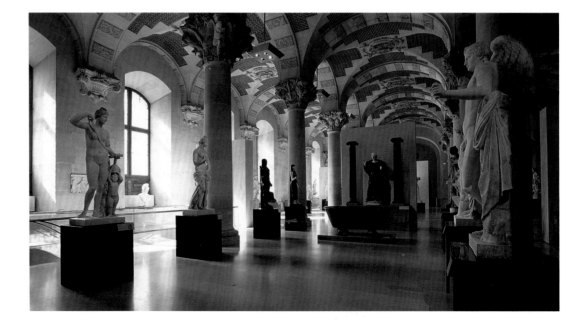

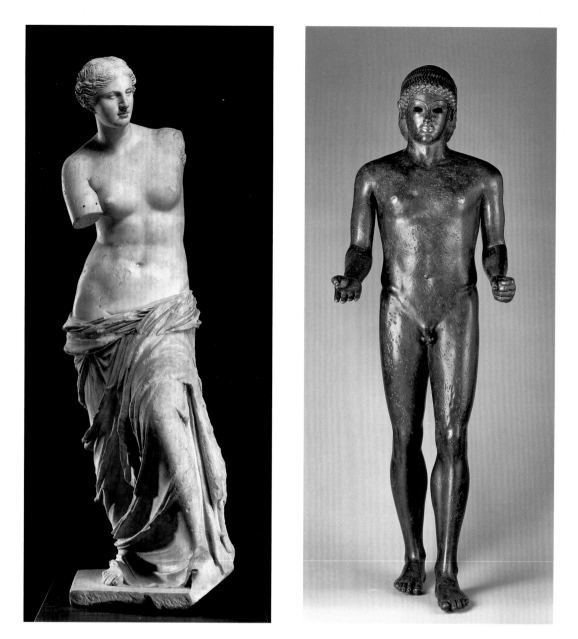

Once the legitimate restitutions decreed by the Congress of Vienna in 1815 had been
effected, the number of antiquities arriving at the Louvre decreased significantly. From then
on, additions to the museum's collections took the form of donations resulting from diverse
political or military events, or of dispatches following agreements concluded by scientific and
diplomatic expeditions. It was in this way, for example, that the *Venus de Milo* (fig. 12) and the
*Apollo of Piombino* (fig. 13) arrived at the Louvre. The French monarchy of the Restoration
missed no opportunity to enrich the museum, and moreover widened the range of objects col-
lected. From the sculptures, sarcophagi, and reliefs that had held sway until this period, they now
extended the collection to include a large number of small objects, such as vases and statuettes
in bronze and clay. With the purchase of the Tochon collection and the two Durand collections,
the Louvre became the proud possessor of a considerable number of vases and statues in bronze
and terracotta.

The period of the Second Empire was particularly brilliant for the Department. Follow-
ing the arrival (in several shipments) of the *Victory of Samothrace* (fig. 14), the Louvre made an

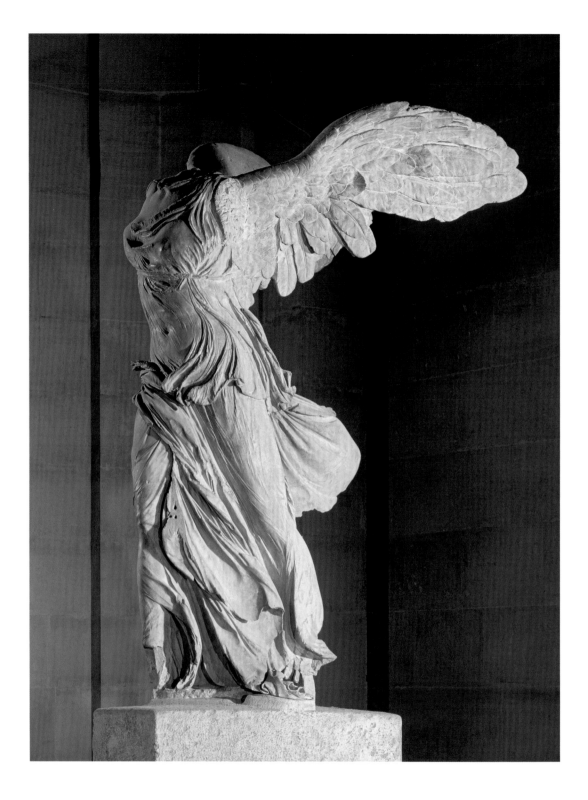

acquisition of paramount importance, that of the Campana collection, consisting of an extraor-
dinary ensemble of Etruscan antiques and an incomparable collection of Greek vases. The
Campana collection had been constituted from objects excavated in the Etruscan necropolis of
Cerveteri; it included both everyday objects from the area around Cerveteri and a large number
of the Greek vases which the Etruscan elite prized so greatly and went to such pains to acquire.

A significant group of major antiquities arrived at the Louvre toward the end of the twenti-
eth century, a period marked by the discovery of Greek Archaic art, which until then had been

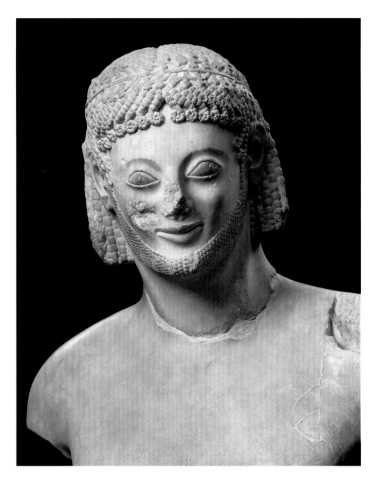

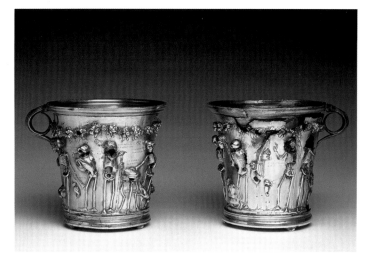

Fig. 15. Head of the *Rampin Horseman,* Greek, Archaic period, ca. 620–480 BC, marble, 10⅝ inches high, Musée du Louvre, Department of Greek, Etruscan, and Roman Antiquities, Ma 3104.

Fig. 16. Pair of cups with skeleton decorations from Boscoreale, Roman, 1st century AD, silver, 4⅛ × 4⅛ inches each, Musée du Louvre, Department of Greek, Etruscan, and Roman Antiquities, Bj 1923–Bj 1924.

little-known or -appreciated. During the renovation leading to the opening of the Grand Louvre, the Gallery of Pre-Classical Greece was specially arranged to present this wide variety of objects, ranging from small Corinthian vases to major marble statues such as the *Kore of Samos* or the head of the *Rampin Horseman* (fig. 15), and to illustrate the early period of Greek creation, when the different Greek cities competed with each other and strove to assert their separate identities through the excellence and individuality of their artistic creation. Athens played a major role in this movement, but so did the Ionian and Cyclades islands, where there were a number of brilliant artistic centers. The end of the nineteenth century also witnessed the acquisition by the Louvre of the superb collection of Roman silver discovered at Boscoreale near Pompeii (fig. 16).

Although, following the application of more stringent rules regulating the movement of archaeological objects, there was a certain loss of momentum in the rate of the Department's acquisitions during the twentieth century, the Department has nevertheless been able to extend its collections by means of a number of judicious purchases in the art market. In addition, several donations have greatly contributed to the enrichment of the collections.

Henceforth, acquisitions will be exceptional, possible only when works belonging to existing private collections appear on the market. The countries where original Greek, Etruscan, and Roman antiquities are to be found now exercise a very restrictive policy, making it virtually impossible to purchase antiquities. A major turning point has thus been reached in the history of archaeological departments, not only in the Louvre but in museums throughout the world.

# I

*Attic amphora with black figures*
Attributed to Group E, signed by Exekias as potter

Greek, found in Vulci (Italy), 550–540 BC
Clay
17½ × 12 inches (44.5 × 30.5 cm)
Department of Greek, Etruscan, and Roman Antiquities, F 53

This amphora, which arrived at the Louvre in 1883, was discovered in Vulci and thereafter belonged in succession to the Durand, Magnoncourt, and Roger collections. Its front side shows the tenth of the twelve labors that Eurystheus ordered his cousin Herakles to complete: capturing the herd of oxen that belonged to the ferocious three-bodied monster Geryon.

Herakles is represented wearing the *leonte* (the skin of the Nemean lion, which he was required to kill for his first task). Sword in hand, he is about to attack the monstrous Geryon, made up of three bodies of hoplites attached at the torso. Wearing helmets and armor, they are protecting themselves with their shields (note the marvelous *episeme* in the shape of a gorgoneion).[1] One of the bodies turns away, already wounded by one of Herakles's arrows. Eurytion lies on the ground, his head also pierced by an arrow. He is the keeper of Geryon's herd of cattle, as indicated by the cap he wears. Several inscriptions provide us with the names of the characters as well as that of the potter Exekias, whose signature can be found behind the figure of Herakles.

J. D. Beazley attributed the vase to Group E rather than to Exekias himself because of some archaic traces in the setting—such as the motif of the siren visible on the other side, which represents a departure in a quadriga (a two-wheeled chariot drawn by four horses)—and on the lid.[2] Nevertheless, the very high quality of the drawing, the precision of the incisions, and the clarity of the design, as well as the handwriting in the inscriptions—resembling that of the signature—show a striking resemblance to the style of Exekias, the greatest black-figure artist of the sixth century BC.

**SOPHIE PADEL-IMBAUD**

NOTES

1. The *episeme* is a shield's ornament, usually in its center. Here it shows the gorgoneion, the decapitated head of the gorgon Medusa, which frequently appears as an *episeme* ornament because its shape is well-adapted to the shield and its symbolism is so terrifying.

2. Sir J. D. Beazley (1885–1970) was the great specialist of Greek ceramics to whom we owe the attribution of most of the Attic vases. When signatures were missing, he gave conventional names to the painters.

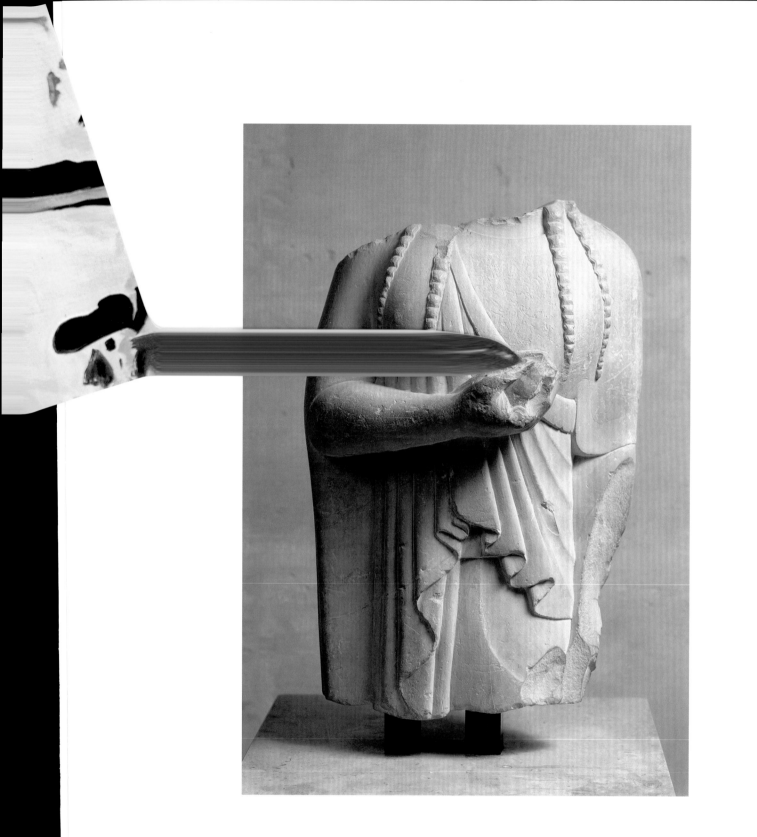

## 2

*Torso of a statue of a draped maiden (kore) holding a bird*

Greek, found in Clazomènes (Turkey), 530–520 BC
Limestone with traces of red paint
16½ inches (41.9 cm) high
Department of Greek, Etruscan, and Roman Antiquities, Ma 3303

# 5
## *Funerary stele of Philis*

Greek, found in Port of Panagia, Limenas, island of Thasos, ca. 450 BC
Marble from Thasos
60¼ × 35⅞ × 7 inches (153 × 91.2 × 17.8 cm)
Department of Greek, Etruscan, and Roman Antiquities, Ma 766

This funerary stele, composed of ten fragments, was discovered around 1862 on the island of Thasos, in the northern part of the Aegean Sea—more specifically, in Limenas, according to E. Miller, who acquired it for France in 1864 during his mission to Mount Athos, Thessaloniki, and Thasos. The initiative of this Hellenist was part of the series of scientific expeditions encouraged under Napoleon III, much like those of Léon Heuzey and Henri Daumet in Macedonia.

The upper and lower parts of the stele are missing, as are the front corner of the seat, the figure's right wrist, and a large triangular fragment in the leg area. Traces of polychromy that were observed at the end of the nineteenth century, notably some pink on the cheek, have disappeared entirely since then. This funerary monument was originally crowned with a triangular pediment in bas-relief. On the band that forms the stele's upper edge, the name of the deceased is written in the Ionian alphabet: "Philis, daughter of Cleomenes." The young woman, in profile toward the right, is seated on a *diphros,* her torso slightly at an angle, her right foot on a low stool with zoomorphic feet. She is detached from the bas-relief field of the stele. Wearing a *kekryphalos* on her head, dressed in a *chiton* and a *himation* that covers her legs and shoulders, the woman bows her head and holds in her left hand a box from which, with her right hand, she is removing a small round object. The gesture has sometimes been interpreted as a mystical allusion: the deceased is taking a scroll of text connected to the secret cult of Demeter from the box. It is more likely, as with most funerary stelae of the fifth century BC, that the scene simply represents the daily life of the deceased: Philis is shown at home, drawing a piece of jewelry or a ribbon from her box.

The exact dating of the work within the fifth century BC continues to be a topic of great debate. The use of the common Ionian alphabet instead of the alphabet from Paros merely indicates that the stele was erected on Thasos after the former Parian colony had come under the protectorate of Athens in 463 BC.

The shallow relief, the face of Philis that stands out because of one heavy-lidded eye, full mouth, and round chin, as well as the very flat snail-curled locks and the handling of the *kekryphalos,* indicate the period of the Severe style, between 480 and 450 BC, placing the work somewhere around 460 BC. However, the treatment of the loose folds in the *chiton* and the heavy flat-crested folds of the *himation,* especially on the hip, evoke the drapery of the goddesses of the frieze of the Panathenaia created at the Parthenon around 440 BC. Could the stele be from the post-Parthenon period? In that case, it would date from around 430 BC.[1]

But the dating of the work can be conceived of without debating a pre- or post-Parthenon date. Indeed, in the Thasos context, the stele of Philis could be a production contemporary with the early stages of the Parthenon site (447–432 BC). As such, the face has the characteristics of the Severe style as it had just been articulated in the Aegean Sea region. At the same time, it already manifests later traits that will be elaborated further in the course of the development of the Parthenon's décor—thanks precisely to the contributions of Greece's island workshops. The stele's creation should therefore be placed between 450 and 440 BC.[2]

LUDOVIC LAUGIER

NOTES
1. *Mer Egée, Grèce des Iles,* exhibition catalogue, Paris, Louvre, 1979, no. 153, pp. 217–218.
2. M. Hamiaux, *La sculpture grecque, I,* Paris, 2001, no. 97, p. 108, with full bibliography.

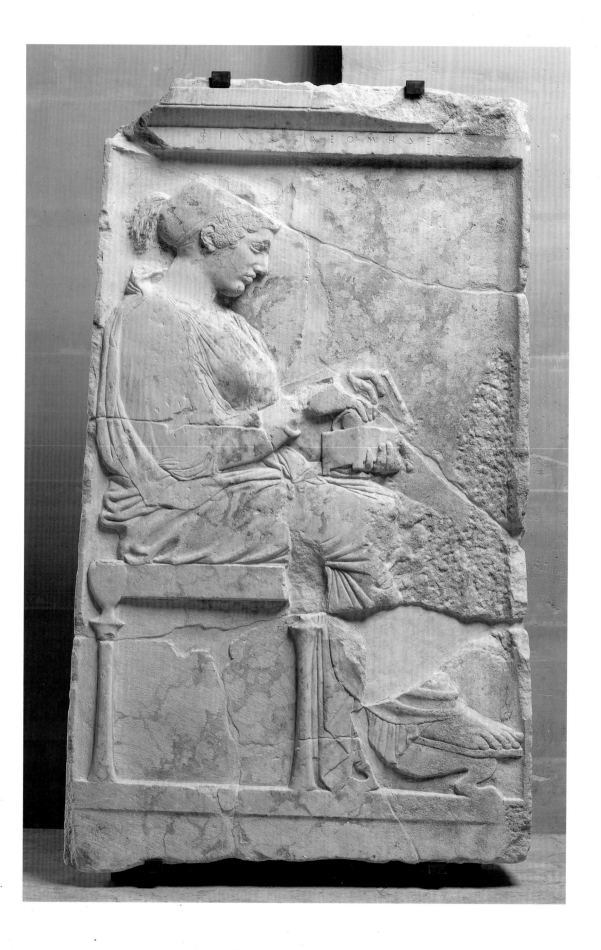

## 6

*The Sophoclean*
Attributed to the Workshop of *The Lady in Blue*

Greek, found in Tanagra (Greece, Beotia), ca. 330–300 BC
Buff-colored, molded, and modeled terracotta. Traces of white
preparation and faint traces of paint: orange-red for the face, red
for the shoes, yellow for the *chiton* (tunic), and blue and violet for
the *himation* (cloak)
11⅜ × 5½ × 3⅛ inches (29.2 × 14 × 7.9 cm)
Department of Greek, Etruscan, and Roman Antiquities, MNB 585

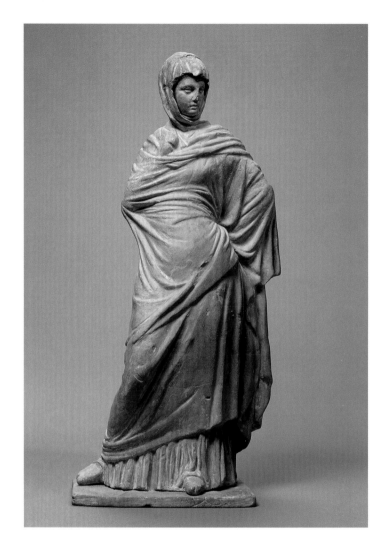

This statuette came to the Louvre in 1874 thanks to
Olivier Rayet, an archaeologist who was present in Athens
at the time the tombs at Tanagra were discovered.[1] Hundreds
of terracottas were brought to light as the result of illicit exca-
vations begun in the latter part of 1870. Closely associated with
religious worship or rites of passage, these figurines of children,
young men, and, above all, draped women, also bore witness
to daily life (clothing style, games, etc.)—an aspect of antiquity
overlooked up to this point by scholars and amateurs alike.

Among the most beautiful of the Tanagra figurines,[2]
*The Sophoclean* gets its name from a portrait of the tragedian
Sophocles, in which the placement of the arms and the
arrangement of the himation are nearly identical. Sometimes
attributed to the Attic sculptor Leochares, the bronze original
of the *Sophocles* was set up in the Theater of Dionysus in Athens
between 338 and 324 BC. The prototype of the figurine—
probably made shortly afterwards in an Athenian workshop—
served as a constant source of inspiration to workshops
throughout the Greek world. But it was at Tanagra, with
this copy, that it reached its finest form.

*The Sophoclean*'s plastic qualities recall *The Lady in Blue,*
another Tanagra statuette in the Louvre. The similarity of
the clay used in their manufacture, confirmed by laboratory
analyses, leads one to conclude that the two works are crea-
tions of the same workshop. Microscopic examination made
on *The Sophoclean* at the time of its 2002 restoration by Pascale
Klein have proven that, like *The Lady in Blue,* it had originally
been richly polychromed.

JULIETTE BECQ

NOTES
1. For the most recent presentation of Tanagra, see *Tanagra, mythe et archéologie,*
exhibition catalogue, curated under the direction of Violaine Jeammet, Paris,
RMN, 2003; for *The Sophoclean* specifically, see pp. 199–203. The exhibition was
on view at the Louvre, 15 September 2003–5 January 2004, and at the Montreal
Museum of Fine Arts, 5 February–9 May 2004.

2. These figures met with such success that the name Tanagra came to be mis-
leadingly applied to numerous Greek terracottas, even when the production
area and period of creation of the latter had no connection whatsoever with
the Tanagra workshops.

# 7
## *Crouching Aphrodite*

Roman Imperial period, Roman replica
of a 3rd century BC Greek type
Marble
28 inches (71 cm) high, on flat marble base
Royal Collections
Department of Greek, Etruscan, and Roman
Antiquities, Ma 53

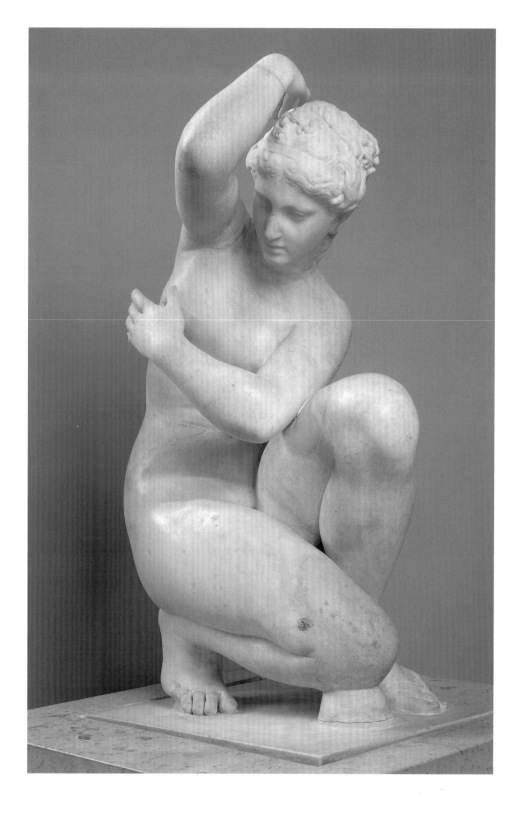

8

*Front of an Etruscan cinerary urn:*
*The Recognition of Paris*

Late 2nd–early 1st century BC
Volterra workshop
Volterra alabaster; high relief
18⅛ × 28¾ × 3⅛ inches (46 × 73 × 8 cm)
Provenance: Pogni (Val d'Elsa, Tuscany); formerly in the Gaddi
Collection, then the Royal Collections (Cabinet du Roi)
Allocated from the Cabinet des Médailles, Bibliothèque nationale
de France, 1929
Department of Greek, Etruscan, and Roman Antiquities, Ma 3605

When this plaque entered the Royal Collections in 1833, it had been known of since at least the beginning of the eighteenth century. In 1723 it was listed in the famous Palazzo Gaddi Collection in Florence, and was subsequently acquired for the Cabinet du Roi by Raoul-Rochette, who immediately published a paper on it in his *Monuments Inédits.*[1]

The scene illustrates a well-known episode from the Trojan legend.[2] Paris spent his childhood on Mount Ida, but once he had grown to manhood he returned to the palace at Troy, where he took part in the funeral games organized by Priam. He so distinguished himself by his bravery that he provoked the resentment of Deiphobus, one of his brothers, who threatened him with his sword. Paris sought refuge at the altar of Zeus, where his sister Cassandra recognized him. This subject, often portrayed in classical Greek tragedy and much appreciated by the Etruscans, was frequently illustrated, particularly on cinerary urns and bronze mirrors.[3]

The identification of the figures on this plaque depends essentially on the appearance, attitudes, and attributes of the figures. Priam, who is positioned on the extreme right and makes a gesture of surprise, is recognizable from his beard, traditionally worn by older men. Paris is shown with his Phrygian cap and the palm of victory and placing one knee on the altar, while Deiphobus comes toward him menacingly, waving his sword. The headless female figure on the extreme left of the scene seems to be Cassandra. The figures standing on either side of the two protagonists are probably Hector and Helenus, Paris's two other brothers. Finally, in the center of the composition, a partially nude Aphrodite, decked out in all her jewels, is depicted beside her protégé.

The artist uses different planes and endows his figures with a wide range of gestures and attitudes; as a result he accentuates the impression of depth and succeeds in giving life to the scene and infusing a sense of drama and solemnity. The modeling of the figures, the anatomic observations, the swelling muscles, the sensuality of the female nude, and the contrasting treatment of the folds all suggest the influence of models originating in Greek workshops in Asia Minor during the second century BC. It was formerly thought that the plaque might have been the work of a Greek artist,[4] until it was recognized as one of the most successful productions of the Volterra workshop, dating from a period when Etruria was integrating the vast cultural and artistic *koinè* of the Hellenistic world.

KATERINA CHATZIEFREMIDOU

NOTES

1. For the history of the discovery of the work, its conservation in Florence, and its acquisition, see M. Martelli, "Un passo de Verino, una collezione, un 'castellum' etrusco," *Prospettiva* 15, 1978, pp. 12–18, which also includes reproductions of the oldest drawings of the plaque (figs. 3 and 6).

2. For a detailed description of the scene, see the recent catalogue by M.-F. Briguet, *Les urnes cinéraires étrusques de l'époque hellénistique,* Paris, RMN, 2002, pp. 163–166, no. 65.

3. We know of about fifty urns, most of which come from Volterra, and some twenty mirrors which treat the same theme. They usually depict only the main personages of the myth.

4. F.-Pairualt, *Recherches sur quelques séries d'urnes de Volterra à représentations mythologiques,* coll. Ecole française de Rome, 12, 1972, p. 258, no. 13.

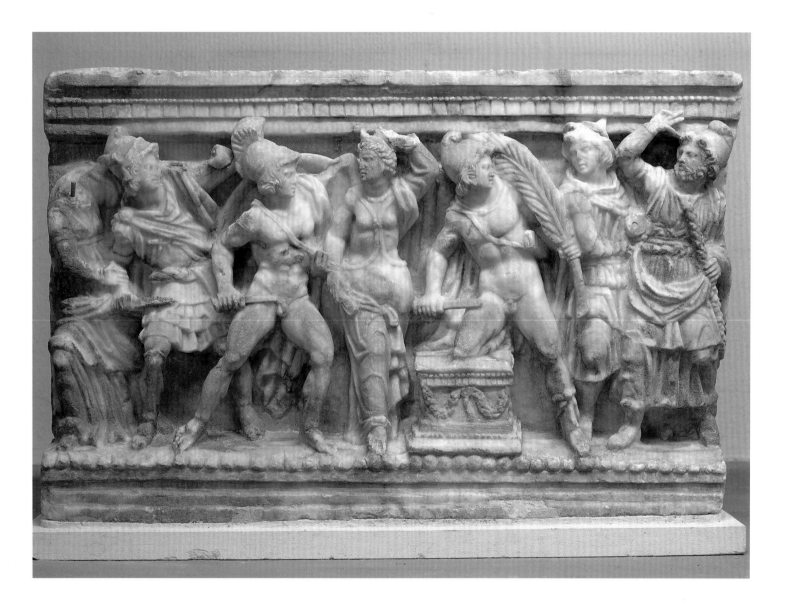

# 9
## *Mercury*

Roman, second quarter of the 1st century AD
Bronze with silver and red copper inlay. Two fixing nails traverse
the feet
8¼ inches (21 cm) high
Royal Collections
Department of Greek, Etruscan, and Roman Antiquities, Br 183

The provenance of this statuette is unknown. It entered the
Royal Collections before 1684 and was one of the few
antique bronzes to be displayed at Versailles in the private apart-
ments of Louis XIV. However, interest in the bronze did not
last long, and at the beginning of the eighteenth century it was
placed in the Garde-Meuble de la Couronne (the Royal Stores),
where it remained until the end of the Ancien Régime. In both
the 1788 inventory and the *Diamans de la Couronne* inventory of
1791 it was described as a precious Roman bronze, and on the
22nd of the *pluviôse,* the fifth month of the Republican calendar
(10 February 1797), it was transferred to the Louvre reserves.

The statuette, which was catalogued, rather surprisingly,
alongside modern bronzes and casts of antiques in the Napoleon
Museum, soon found its way back to the storerooms. It was only
recognized as an antique bronze several decades later, when it
was correctly identified in the 1859 inventory as a statuette of
Mercury bereft of its symbolic attributes.[1] The god of commerce
had once displayed a money bag in his right hand and clasped
the staff of his caduceus in his left. The two symmetrical notches
visible in the god's hair above the forehead indicate the places
where there had originally been two little wings.[2] The traces on
the left thumb and forefinger and the three missing fingers of
the right hand suggest that these elements, which had been fixed
separately to the statuette, were wrenched off during antiquity,
probably because they were made of a precious metal. This the-
ory is reinforced by the fact that the lips and nipples are inlaid
with red copper and the eyes with silver.

The statuette is a Roman adaptation of a large-scale bronze
statue created by Polykleitos in about 460 BC. The Polykleitos
statue, which has since disappeared, may have represented a
*discophoros,* for which we have a number of fragmentary marble
replicas. The head is inclined and turned toward the lowered

right shoulder. The right hip is raised, since it is this leg which
supports the weight of the body. The hip of the free-standing left
leg is lowered, while the left shoulder is raised in order to flex
the muscles. The result is that one half of the body is contracted
and taut, while the other half is slack. The overall impression,
however, is one of balance—an equilibrium based on the use
of *contrapposto* and an erudite system of carefully calculated
proportions.

The two feet are flat on the ground. As well as being a
sculptor, Polykleitos was a theoretician and author of the *Canon.*
But when he created the *discophoros* he had only just begun his
research into the question of the stance or pose of a figure, and
had not yet reached the point where he raised the heel of the
foot of the free-standing leg; this latter innovation can be appre-
ciated in his *Doryphoros,* datable to about 440 BC. The particular
stance of the *discophoros* distinguishes it from other works by
Polykleitos, and leads us to relate it to a passage by Pliny the
Elder concerning works by Polykleitos, in which the Roman
writer refers to a "*nudus talo incessens,*" a "naked man walking on
his heel."[3]

SOPHIE DESCAMPS

NOTES

1. *Les Bronzes de la Couronne,* exhibition catalogue, Paris: Musée du Louvre
(12 April–12 July 1999), 1999, no. 85, pp. 28, 44, 99.

2. This type was especially common in the center and northwest of Gaulle and
in Germany. See S. Boucher, *Recherches sur les bronzes figurés de Gaule pré-romaine
et romaine,* Rome (*BEFAR* 228), 1976.

3. Pliny, *Natural History,* XXXIV, 55. For the type of the *discophoros* by Polykleitos,
see P. C. Bol, "Diskophoros," in *Polyklet. Der Bildhauer der griechischen Klassik,*
exhibition catalogue, Frankfurt, Liebieghaus (17 October 1990–20 January 1991),
Frankfurt, 1990, pp. 111–117; A. Leibundgut, "Polykletische Elemente bei spät-
hellenistischen und römischen Kleinbronzen," ibid., pp. 404, 654.

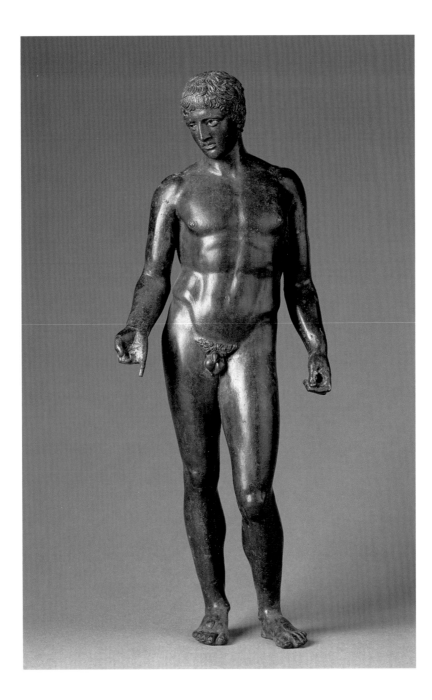

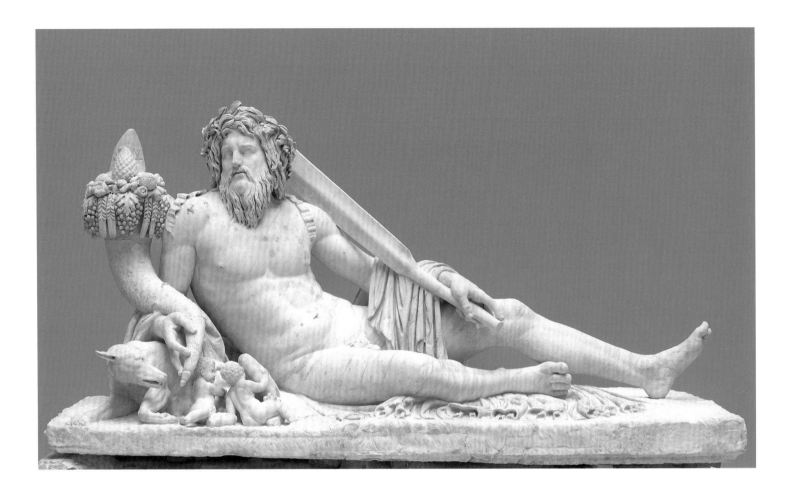

## 10
### *The Tiber*

Roman, found in Rome, Campus Martius (Field of Mars), 75–125 AD
Marble
65 × 124⅞ × 51½ inches (160 × 320 × 130 cm)
Department of Greek, Etruscan, and Roman Antiquities, Ma 593

This statue personifying the River Tiber was discovered in Rome in January 1512, between Santa Maria sopra Minerva and San Stephano del Cacco. Instantly admired, it was promptly acquired by Pope Julius II on 2 February 1512. The pope had at that time assembled an unprecedented collection in the Belvedere Court. *The Tiber* thus joined the *Belvedere Apollo,* the *Laocoön, Emperor Commodus as Hercules,* and the *Venus Felix* in the most prestigious assembly of antique marble statuary in Europe. Indeed, the Belvedere Court was home to the most beautiful ancient statues collected by Popes Julius II, Leon X, Clement VII, and Paul III. In 1513 the statue of *The Nile* was discovered in the same precinct of the city, and in 1523 the two river gods were converted into fountains at the center of the Court.

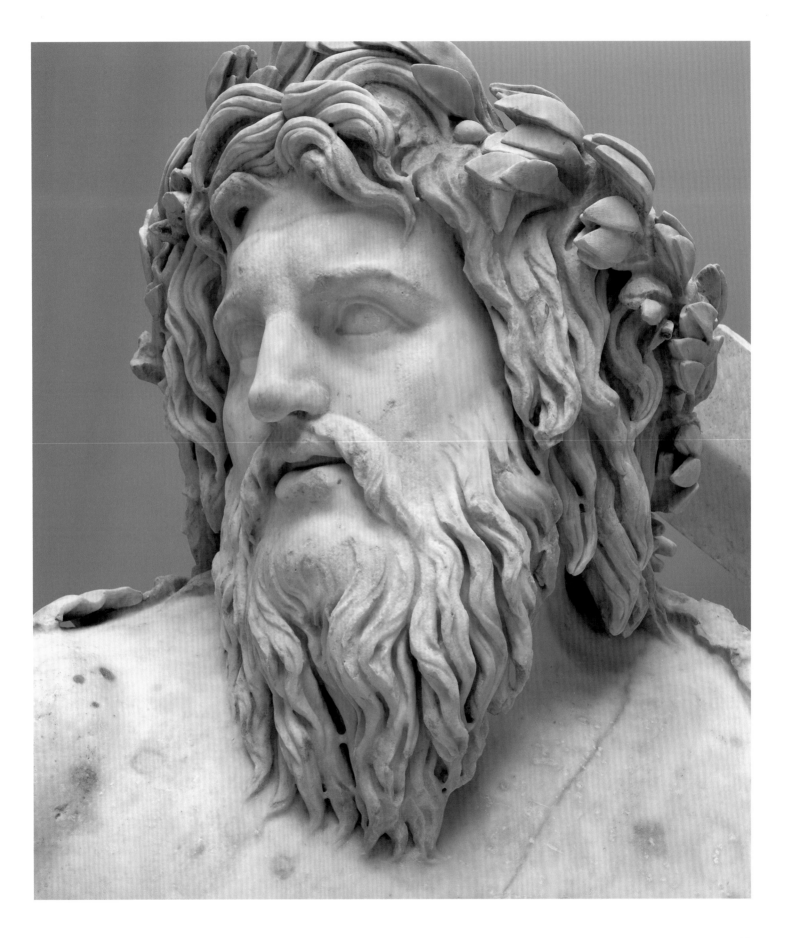

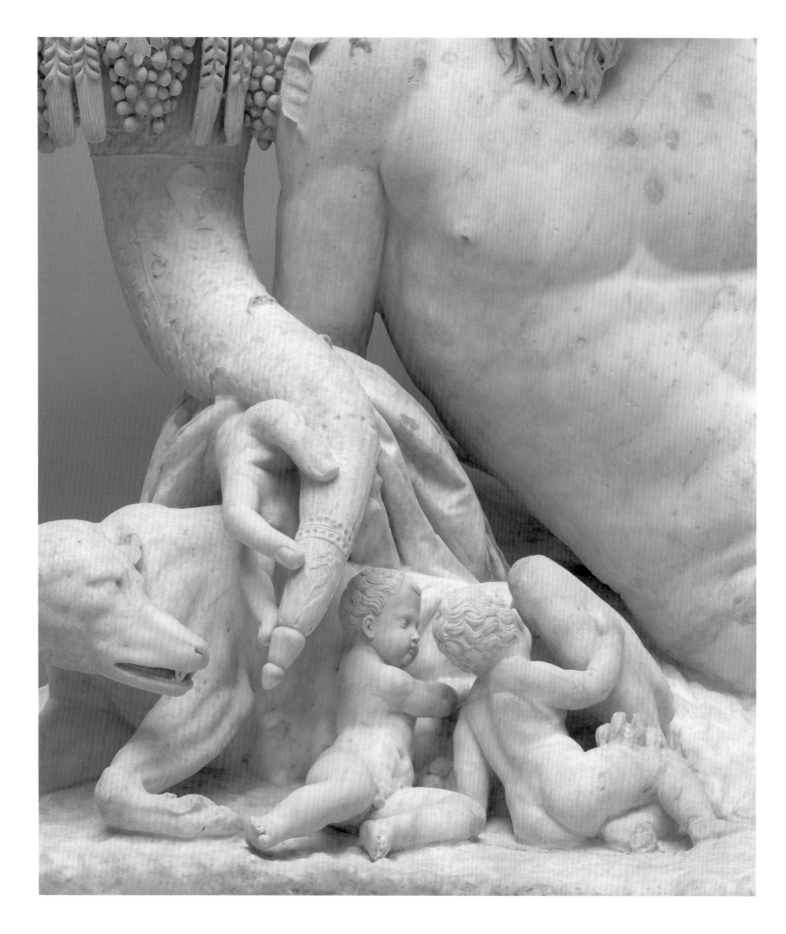

In 1524–1525, the statue was at least partially restored and the figures of Romulus and Remus were completed. Between 1540 and 1543, Primaticcio and Vignola were sent to Rome to take molds of the most highly regarded ancient statues in order to cast bronze copies for the court of François I at Fontainebleau. The bronze of *The Tiber* was melted down into raw bronze in 1792, but in 1715 Pierre Bourdy had sculpted a marble copy for Louis XIV, which was set in the Marly garden and has been in the Tuileries garden since 1719.

*The Tiber* was part of Article XII of the Treaty of Tolentino, signed between France and the Vatican. It arrived in Paris in January 1804 and was installed in the Louvre's Rivers Gallery in 1811. Following the fall of the Empire in 1815, Pius VII offered the sculpture to Louis XVIII in exchange for a statue of Napoleon by Canova.

*The Tiber* stands as an important testament to the monumental sculpture of the Roman period. It was discovered in the ancient precinct of the Campus Martius—more specifically, in the *Iseum Campense,* an important temple of the goddess Isis. The figures of the Tiber and its counterpart statue of the Nile (still at the Vatican Museums in Rome) at one time decorated the sanctuary of Isis and Serapis. *The Tiber* dates from the restoration of the sanctuary, possibly by either the Flavians (69–96 AD) or Hadrian (117–138 AD). The low reliefs on the pedestal are original and illustrate both pastoral and river navigation scenes in addition to a mythological episode alluding to the founding of Ostia.

DANIEL ROGER

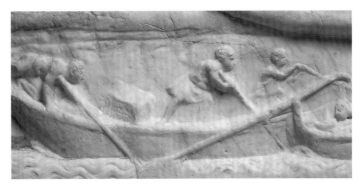

BIBLIOGRAPHY

Haskell, Francis, and Nicholas Penny. *Taste and the Antique. The Lure of Classical Sculpture 1500–1900.* New Haven and London: Yale University Press, pp. 310–311.

Le Gall, Joël. *Recherches sur le culte du Tibre.* Paris: Presses universitaires de France, 1953, pp. 3–23.

LIMC, Lexicon iconographicum mythologiae classicae. Zürich and Munich: Artemis, VIII (1997), p. 26, no. 15.

## II

*Lucius Verus*

Roman, found in Acqua Traversa
(Italy), ca. 161 AD
Marble
30¾ × 20½ × 13¾ inches
(78.1 × 52.1 × 34.9 cm)
Department of Greek, Etruscan,
and Roman Antiquities, Ma 1131

## 12
*Portrait of Antinous*

Roman, ca. 130 AD
Marble
17 × 10¼ × 11 inches (43.2 × 26 × 27.9 cm)
Department of Greek, Etruscan, and Roman
Antiquities, Ma 238

# The Louvre and the
# Birth of Egyptology

# Egyptian Antiquities

*Christiane Ziegler*

Egyptology is a young science, born in the early nineteenth century. Without ignoring the role of the international community in its development, the contributions by French scholars are especially noteworthy, including the first publications of thousand-year-old masterpieces, the deciphering of hieroglyphics, and the organizing of excavations. The traditional connections between France and Egypt and French fascination with the civilization of the pharaohs that began with the Age of Enlightenment play a large role in this history. Later, the establishment of the Department of Egyptian Antiquities at the Musée du Louvre and the influence of the French excavations in Egypt reinforced the scientific collaboration, which continues to be very lively today. In contrast to what is generally believed, the Louvre's Department of Egyptian Antiquities owes nothing to Napoleon Bonaparte's Egyptian expedition of 1799. The objects collected by the scholars who accompanied him are in the British Museum today—beginning with the famous Rosetta Stone (fig. 1)—for at the time

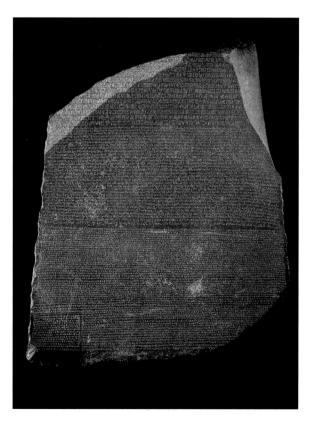

Fig. 1. Rosetta Stone, Egyptian, Ptolemaic era, 196 BC, granodiorite, 45 × 28½ × 10⅞ inches, British Museum, London.

## Bonabes de Rougé
*Bust of Jean-François Champollion, 1863*

Marble
25³⁄₁₆ × 13¹³⁄₁₆ × 12 inches (64 × 35 × 30.5 cm)
Signed and dated on the side: Vte B. de Rougé 1863
Department of Sculptures, RF 4637

In 1822, Jean-François Champollion (1790–1832) deciphered the Egyptian writing system. Following the creation of an Egyptian section of the Louvre in 1826, he became the first curator of what is now the Department of Egyptian Antiquities. In order to present the art and civilization of ancient Egypt, the founder of scientific Egyptology organized the galleries according to daring, avant-garde museological principles—an accomplishment unique in museum history. In this period that saw the Greco-Roman aesthetic at its height, the public was able to discover both the diversity and the splendor of Egyptian art at the same time.

Contrary to a commonly held myth, Champollion was not part of Napoleon's expedition in Egypt, nor was he present in Rosetta when the famous "stone" was discovered. He was eight years old at that time, but had already demonstrated the extraordinary gift for languages that would allow him to decipher, translate, and set down a grammar of the ancient Egyptian language. It was not until 1828 that he made his only journey to Egypt, where he was able to test the accuracy of all his theories and acquire objects later to be turned over to the Louvre upon his return.

This bust, made more than thirty years after his death, pays homage to Champollion's genius by representing him nude, like a hero of antiquity, but with his name on the front and his nineteenth-century muttonchops upon his cheeks. After its exhibition at the 1864 Salon, the bust was purchased to decorate the galleries of the Louvre's Egyptian Department.

**MARC ETIENNE**

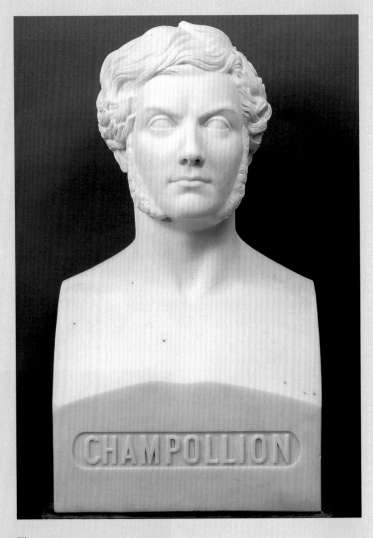

Fig. 2.

there was no Egyptian department at the Louvre and the museum world paid scant attention to Egyptian art.

It was Jean-François Champollion (fig. 2) who persuaded King Charles X to house the objects of this great civilization at the Louvre. By decree, a division of Egyptian monuments was created at the Royal Museum of the Louvre on 15 May 1826, and Champollion was named as its curator. No better choice could have been made than the universally recognized genius who had solved the mystery of hieroglyphic writing in 1822 and established the new science of Egyptology.

Born in 1790 in Figeac, Champollion was a child prodigy with a passion for ancient forms of writing that began in early childhood. With the support of his older brother, the erudite Champollion-Figeac, he became a professor at the University of Grenoble at the age of nineteen. A historian and philologist, he started by studying from books before he discovered the Egyptian masterpieces that came to Europe early in the nineteenth century. After establishing the Egyptian Department of the Louvre Museum, he led a scientific expedition to Egypt that picked up where Napoleon left off. Named a member of the Académie des Inscriptions et Belles-Lettres in 1830 and then professor at the Collège de France in 1831, he succumbed to exhaustion and died in 1832. His short life was wholly devoted to the study of Egyptian civilization, the key to which lay in the secret of its writing.

The last hieroglyphic inscriptions were carved on the island of Philae and date from the fourth century AD. The knowledge of this mysterious script seems to have disappeared very quickly once Christianity triumphed and the Coptic script was adopted, which uses Greek letters and seven special signs that came from the Demotic (fig. 3).

Fig. 3. Coptic parchment, Gospel of Luke, chapter 7, verses 12b–22b, Musée du Louvre, Department of Egyptian Antiquities, E 9970.

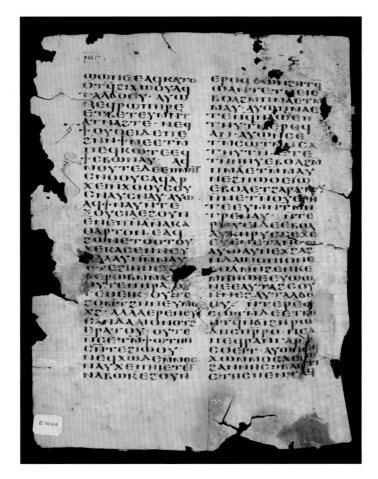

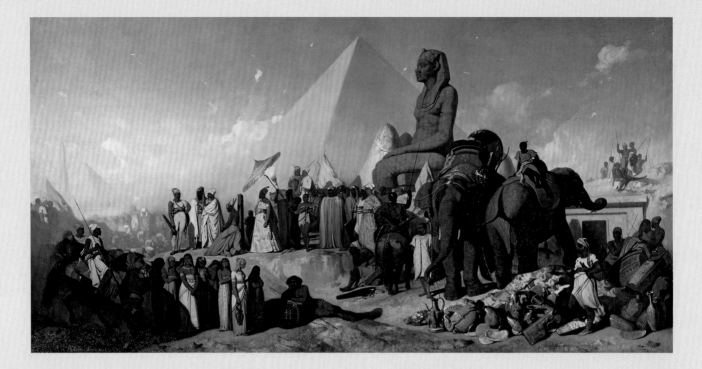

Fig. 4.

## Adrien Guignet (1816–1854)
*Cambyses and Psammenitus, 1841*

Oil on canvas
44⅞ × 83⅛ inches (114 × 211 cm)
Purchased at the 1841 Salon
Department of Paintings, INV 5255

Before J. F. Champollion deciphered the Egyptian hieroglyphic writing system, the sole descriptions of Egyptian civilization available had been accounts by Greek and Roman travelers and those books of the Bible dealing with Egypt, notably Exodus and Kings. Among the accounts by Greek travelers, that of Herodotus in *The Histories* is the most important. He provides accounts of Egyptian civilization as seen by a Greek traveling in Egypt in the sixth century BC, when it was still under Persian rule.

This painting's subject is taken from an episode of the Persian conquest as told by Herodotus. The Persian ruler Cambyses has just conquered the country after having beaten the Egyptian army and sacked the city of Memphis, the strategic linchpin to the south of the country. As described by Herodotus, Cambyses was a bloodthirsty and cruel king who had the defeated Pharaoh Psammenitus brought before him. This pharaoh was in fact Psamtik III, son of King Amasis. The Persian conqueror is represented here under a parasol while the vanquished Pharaoh, identifiable by the Double Crown of Upper and Lower Egypt (the Pschent crown), is seated to his left, despondent.

To humiliate his defeated opponent and test his spirit, Cambyses had the Pharaoh's daughter dressed as a slave and forced her to draw water from a well. Psammenitus recognized his daughter, bucket in hand, and wordlessly lowered his head, while the other Egyptian dignitaries wept, seeing their own children forced to submit to the same fate. In portraying this scene, the artist remains faithful to Herodotus's account. The landscape, on the other hand, is rather fanciful, reflecting an imaginary and suggestive image of Egypt characteristic of Orientalist painting, mixing facts with fiction.

The scene is supposed to take place on the outskirts of the palm grove of Memphis; however, this is an idealized view of the Giza Plateau. The three famous pyramids are juxtaposed against an imaginary obelisk in the background, with a colossal statue. This statue is in fact that of an unknown pharaoh, probably one of the successors to Akhenaten, forming part of a royal group (N 831). The work, which is in the collection of the Egyptian Department of the Louvre and stands only 25¼ inches (64 cm) high, served as a model for the artist, who had studied it in the museum's galleries.

MARC ETIENNE

From the middle of the fifth century AD on, the only information we have on hieroglyphics comes from Classical authors (fig. 4) and the first Church Fathers. The evidence is confusing and often contradictory. We owe the most interesting accounts to the writer Horapollon, who lived in Egypt in the second half of the fifth century and left a whole treatise on hieroglyphics inspired by a work that was three hundred years older. Unfortunately, in the middle of the seventeenth century the Jesuit Athanase Kircher took it upon himself to explain the hieroglyphic system, relying essentially on this text. Starting from the perfectly accurate principle of the relationship between Coptic—still spoken at the time in the Egyptian church—and ancient Egyptian, Kircher came up with some lamentable results. His mistake was to attribute symbolic values to the hieroglyphics, following the theories of the neo-Platonic philosopher Iamblichus, among others.

Champollion himself would not escape from the same delusion: until early September 1822, he continued to believe that his hieroglyphic alphabet was valid only for writing foreign names. He had actually established this, aided by the names of Ptolemaic sovereigns (Ptolemy, Cleopatra, and so on), which were recognizable by their cartouches. These names shared common letters and existed in Greek translation. Until that time, Champollion remained convinced that the pharaonic writing was symbolic and figurative. However, when he received the rubbings of the inscriptions from the Temple of Abu Simbel on 14 September 1822, he saw the light. In the cartouche (fig. 5), he immediately recognized the letter *S* from his alphabet. He had reason to believe that the sign was linked to the verb "to be born," pronounced *mas* in Coptic. Still relying on the Coptic, in which he had astounding expertise, he believed that the first sign, a sun, could be read *Re* or *Ra*. The resulting *Ra-ms-s* was the name of one of the pharaohs most

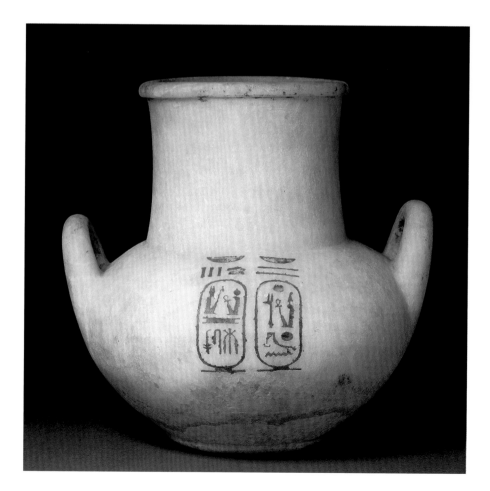

Fig. 5. *Vase with the two cartouches of Rameses II,* Egyptian, New Kingdom, ca. 1295–1069 BC, alabaster, 10⅜ × 10¹¹⁄₁₆ inches, Musée du Louvre, Department of Egyptian Antiquities, E 898.

Fig. 6. Champollion's *Grammaire Egyptienne,* 1836, Musée du Louvre.

Fig. 7. Joseph Gabriel Sentis de Villemür (1855– ?), *Auguste Mariette (Boulogne, 1821–Le Caire, 1881),* 1895 copy of an original sculpted in 1879 by Alfred Jacquemart, marble, 21⁵⁄₁₆ × 18⅞ × 14⅝ inches, Musée du Louvre, Department of Sculptures, RF 4558.

frequently mentioned by the Ancients. One part of the word was written phonetically, the other ideographically, and the whole was revealed as a royal name through his use of the cartouche. In just a few hours Champollion discovered an analogous structure in the name of the famous King *Dhwty-ms,* whom the Greeks called Tuthmose. From that moment on, he understood the principle of the hieroglyphic system, which he explained a few days later in a communication to the Académie known as the famous "Letter to Monsieur Dacier." He was able to take it a step further, having in his possession a copy of the well-known Rosetta Stone, a document whose role was decisive in deciphering hieroglyphics. It contains the text of the same decree by Ptolemy V (196 BC) in three scripts—hieroglyphics, Demotic, and Greek. It had been discovered in Rosetta, east of Alexandria, by Pierre-François-Xavier Bouchard, one of Bonaparte's officers, and was appropriated by the English in 1801 after the capitulation of Menou; it is presently in the British Museum. In 1802, Silvestre de Sacy and Johan David Åkerblad managed to recognize the name *Ptolemy* in the Demotic text. In the hieroglyphic section, which unfortunately is fragmentary, the Englishman Thomas Young had identified the names of Ptolemy and Berenice without being able to explain the significance of the signs.

Within a few years, Champollion gathered all the material needed for two brilliant works, his *Grammaire* (fig. 6) and his *Dictionnaire.* Published after his premature death at the age of 42, they formed the basis of the new science of Egyptology and provided the necessary tools for the knowledge and understanding of one of the great ancient civilizations.

Fewer than twenty years later, a young Egyptologist entered the Louvre as a simple attaché. His name was Auguste Mariette (fig. 7). Recruited to catalogue the papyrus collection, he maniacally copied every document preserved in the Egyptian department. However, his career as epigrapher would take an unexpected turn. On 2 October 1850, the young man disembarked in Alexandria, where his mission was to visit the Coptic monasteries of Egypt and inventory the manuscripts they contained. Mariette achieved his secret dream when he hired thirty workers to explore the desert of Saqqara in search of the Serapeum, a large temple to the god Serapis and the necropolis of the Apis bulls. It was the beginning of one of the greatest adventures in archaeology: guided by the avenue of sphinxes he excavated from the banked-up sands, Mariette reached first the temple and then the tomb in which the pharaohs buried the Apis bulls, living images of the god Ptah of Memphis. Thanks to the generosity of the Egyptian viceroy, two hundred and thirty huge crates filled with ancient artifacts were sent to France to enrich the collections of the Louvre.

"I feel," Mariette wrote, "that the excavations of the Serapeum led to the discovery of roughly seven thousand art objects." The majority of these came from the actual

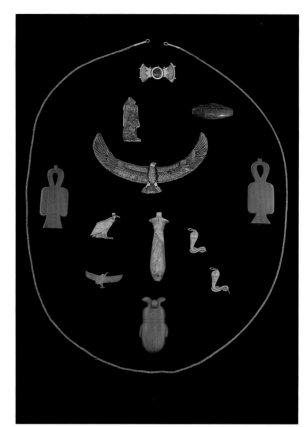

Fig. 8. *The Apis Bull,* reign of Nectanebo I, 30th Dynasty, ca. 379–361 BC, Serapeum of Saqqara, limestone formerly painted, 49⅝ × 69⁵⁄₁₆ inches, Musée du Louvre, Department of Egyptian Antiquities, N 390.

Fig. 9. Jewelry belonging to Khâemouaset, son of Rameses II, ca. 1225 BC, gold, turquoise, cornelian, lapis lazuli, glass, jasper, amazonite, electrum, various dimensions, Musée du Louvre, Department of Egyptian Antiquities, E 2989, N 766, E 2988, AF 2333, E 2990A, E 77, E 82A, E 82B, E 73, N 755A.

Serapeum, including some significant pieces such as the monumental statue of the Apis bull (fig. 8) and the jewelry of the son of Rameses II (fig. 9). Most of the artifacts are more modest but of immense scientific interest: hundreds of stelae dedicated to private individuals, funerary furnishings, fragments of statues and monuments, and many bronze *ex votos* (votive offerings). In addition to these, there was the group of objects from still older tombs, many dating from the time of the pyramids, which the excavator had found. That is when most of the statues of the Old Kingdom came to the museum, including the famous *Seated Scribe* (fig. 10). In 1852, the arrival and exhibition of the Serapeum jewels in Paris aroused an enthusiastic interest in Egypt, an interest maintained through new artifacts that their discoverer made known not only to scholarly circles, but also to the entourage of Napoleon III.

Mariette was a curator at the Louvre, but he yearned to get back to Egypt. He was given an opportunity through a travel initiative that Prince Napoleon, an art-lover and a cousin of the Emperor, wanted to undertake. In the early months of 1857, Mariette had met Ferdinand de Lesseps who, thanks to his Suez Canal excavation project, had gained the favor of Saïd Pasha. The archaeologist managed to convince him of the danger that threatened the pharaonic monuments.

Saïd Pasha assigned Mariette to prepare Prince Napoleon's journey, to precede the prince, carry out the excavations, and rebury his discoveries in the prince's path. That is how the

## 13
### *Fragment of a statue of King Sesostris III*

Egypt, Middle Kingdom, 12th Dynasty
Reign of Sesostris III, ca. 1862–1843 BC
Quartzite
8⅛ × 8⅞ × 9¼ inches (20.5 × 22.5 × 23.5 cm)
Gift of M. Sameda, 1952
Department of Egyptian Antiquities, E 25370

Sesostris III was a ruler of the foremost importance during the Twelfth Dynasty and it was hardly by accident that he was one of the most portrayed kings in all of Egyptian statuary. Every important Egyptian collection contains one or more images of this king, and the Louvre possesses many of the most valuable examples, including two diorite statues that show the seated ruler in traditional dress, with a pleated loincloth cinched by a belt inscribed with his name. But the faces of the two statues are not the same. In a shift never seen before the Middle Kingdom, they portray the king at two different ages: one as a young man and the other as a man clearly marked by age.

This statue fragment shows the ruler wearing the royal head-dress, the "nemes," covering his head. The face is one of a king at the prime of his middle years. The face of the aging man is marked by downcast eyes with heavy eyelids and cheeks beginning to be scored by wrinkles. More complete statues showing this type of face, by contrast, present an athletic torso of a much younger man. Thus, one cannot speak of a "portrait" in the strict sense of the term.

While no ancient document clearly explains what motivated Sesostris III, hypotheses abound. Some Egyptologists took it as a sign of a social revolution transcribed into stone after the unrest following the collapse of the Old Kingdom. Others saw it instead as a representation of life's cycles. Still others took it to refer to an aspect of the cult of the god Osiris, the latter being the nocturnal counterpart of the sun god preparing for his rebirth. This way, the pharaoh, identified with Osiris, would guarantee the everlasting existence of the country. Whether as a shift in religion or politics or as an intellectual revolution, the pharaoh guards his secret while attesting to his power.

MARC ETIENNE

## 14
### *Statue of Nebit, Head of Police*

Egypt, Middle Kingdom, 13th Dynasty, 1782–1720 BC
Diorite
30⅛ × 4⅞ × 18¾ inches (76.5 × 12.4 × 47.6 cm)
Department of Egyptian Antiquities, E 14330

## 15
### *Offerings tablet*

Egypt, Middle Kingdom, 13th Dynasty, 1782–1720 BC
Diorite
3⅜ × 14⅜ × 19½ inches (8.6 × 36.6 × 49.5 cm)
Department of Egyptian Antiquities, E 14410

## 16

*The goddess Sekhmet*

Egypt, New Kingdom, 18th Dynasty,
Reign of Amenhotep III, 1391–1353 BC
Diorite
64½ × 17¾ × 25½ inches (163.8 × 45.1 × 64.8 cm)
Provenance: Luxor, Temple of Mut (east bank) or
Kom el Hetan (west bank)
Acquired 1826, purchase, former Salt collection
Department of Egyptian Antiquities, A 10

Sekhmet ("the powerful" in ancient Egyptian) represents the destructive forces of the sun god. She is the incarnation of the furious eye of the god Re, sent to punish humankind for its armed revolt against him. She is presented in her female aspect (in Egyptian, the word for "eye" is feminine) with the head of a lioness—a fearsome and savage huntress. The disk decorated with the symbol of the cobra (uraeus-cobra) making up her headdress and signaling her connection with the Sun is missing here. Seated on a block throne, hands on her knees, the goddess wears a pleated tunic decorated with flowers. Her jewelry consists of a broad necklace and wrist and ankle bracelets consistent with New Empire style.

She rests her hands on her knees and in her left hand she holds the ankh, the Egyptian symbol of life. Indeed, she possesses the power to unleash all the deadliest catastrophes: epidemics, draught, chaos. Yet, like all Egyptian gods, she has more than one side—she can just as easily cure or eradicate all sickness. Consequently, this dreadful aspect of her nature must be perpetually appeased, since like all goddesses she may assume it whenever angered. In the litanies and daily rites addressed to Sekhmet, Egypt is depicted as a paradise held in a state of perfection. Each statue of the goddess thus represents a litany of invocations to her, transposed into statuary form, designed to propitiate her violent nature.

This statue was sculpted along with hundreds of others for the "mortuary" temple of Amenhotep III on Luxor's west bank. The famous Colossi of Memnon are the sole standing remnants of that temple. It may be that Amenhotep III had installed two sets of 365 statues of Sekhmet within his temple, many of which were later reinstalled in the Temple of Mut, wife of the god Amun.

MARC ETIENNE

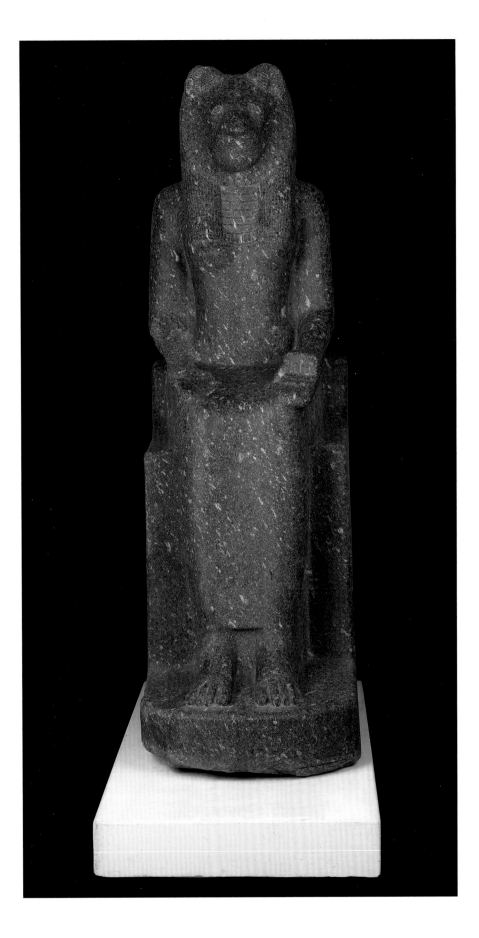

# 17
*Bas-relief with profile of Rameses II*

Egypt, New Kingdom, 19th Dynasty, 1292–1152 BC
Painted limestone
8⅜ × 19½ inches (21.3 × 49.5 cm)
Department of Egyptian Antiquities, E 22764

## 18

*Abbreviated Book of the Dead of Djedkhonsouefankh—*
*first page*

Egypt, Third Intermediate Period, 1075–715 BC
Ink and paint on papyrus
9⅞ × 86¼ inches (25.1 × 219.1 cm)
Department of Egyptian Antiquities, N 3280

# 19

*Statue of Neshor*

Egypt, 26th Dynasty, Saite Period,
Reign of Apries, 589–570 BC
Diorite
40½ × 14¾ × 20⅛ inches (103 × 37.5 × 51.1 cm)
Provenance: Elephantine Egypt, Temple of Khnum, according to
iconography found in the Via Flaminia in Rigano (near Rome)
in the 17th century
Purchase, former Albani collection
Department of Egyptian Antiquities, A 90

This statue represents the kneeling figure of Neshor, holding a statuary group representing the patron divinities of Elephantine, a city in the southernmost portion of Egypt on an island facing what is today Aswan. According to the Egyptians, it was the source for the Nile flood that the ram god Khnum would unleash and the arrival and ebbing of which the goddesses Satis and Anukis oversaw. The simplicity of both Neshor's clothing and the rendering of his figure, together with the choice of dark stone, is characteristic of Twenty-sixth Dynasty style. The high polish, the headdress, and the faint smile are also typical of the art of this period.

Neshor held important positions, both military and administrative—the latter specifically concerning customs tariffs. He is known from numerous other fragmentary statues throughout Egypt. The inscription on the back pillar is a biography that recounts the works that Neshor accomplished for the temple of the patron gods to the temple of Elephantine, who are represented by the group he holds. It further details that the statue was placed in one of the temples of this city to perpetuate the memory and name of its generous benefactor.

This statue stands as an important milestone in the history of Egyptology. It was transported to Rome sometime in the first or second century AD to decorate either a private or imperial residence. In the seventeenth century, it was rediscovered mutilated along the side of an ancient road on the outskirts of Rome. Its inscriptions were copied by the seventeenth-century Jesuit Athanase Kircher, who had set about deciphering Egyptian hieroglyphics and copied out other inscriptions from monuments in Rome, notably from obelisks still in Rome, mostly in the Piazza del Popolo. His works were widely distributed throughout Europe by means of prints and engravings, making this statue famous. In the eighteenth century, during a time of renewed taste for Egyptian antiquities, the statue was restored: Neshor's nose was remodeled as a Greek nose, and the ram god Khnum and his consorts Satis and Anukis were transformed to resemble the god Osiris and his sisters Isis and Nephthys, who were better known at that time. The statue was exhibited in the Villa Albani in an Egyptian-inspired setting, complementing an important group of works from the Pharaonic period. Following its purchase, the work came to the Louvre, where Champollion was able to study its inscriptions as part of his work in deciphering hieroglyphics.

MARC ETIENNE

64

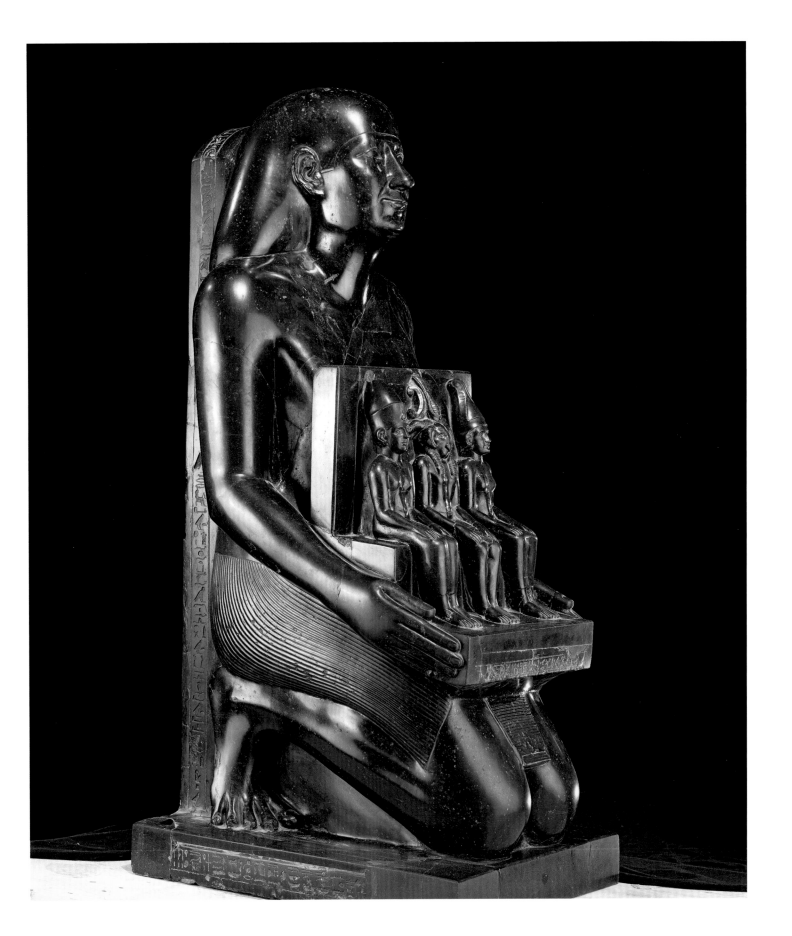

## 20

*Block statue of Wahibre, Governor of Upper Egypt*

Egypt, Late Period, 715–332 BC
Diorite
40¼ × 17¾ × 26 inches (102 × 45.1 × 66 cm)
Acquired as gift of M. de la Turbie, 1822
Department of Egyptian Antiquities, MR 3, A 91, N 92

This larger-than-lifesize statue shows a seated man with folded arms and legs whose body is entirely wrapped in a cloak. The resulting form is simplified, though the volume of the concealed body can be felt in the feet, the shoulders, the back, and the legs, and can be traced in the fine rendering of the body's shape from the sides of the statue. The hands are half-submerged into the material and almost completely blend into the mass of the stone. The neckless head sits almost directly upon the shoulders, as though rising from the surface of the cloak. The face and body are unified by the headdress, which picks up the exterior line of the shoulders and protects the head. The facial features are devoid of personality or wrinkles; it is a face emptied of all expression except for the trace of a faint smile. In light of the subtlety of this particular sculpture, the term "block statue" given to these kinds of works seems inappropriate. There is nothing to disturb the legibility of the composition: the short inscription is collected into lines on the front surface like a placard held up to anyone approaching the statue. The simplicity in the rendering of the body and its soft modeling—together with the pleasant expression of the face—recalls the characteristic style of the sixth century BC and of the art of the Twenty-sixth Dynasty, often called the Saite Dynasty. The name is taken from the Delta city of Sais, where the kings of that era had established their capital.

The man called Wahibre was a high dignitary, having set this statue in the temple of the goddess Neith, patroness of that city. The inscription, in highly sober and slender hieroglyphs, states his titles and closes with his name. During the first millennium, these block statues, placed within temple courtyards, became the preferred monuments for private votive texts. The front surface was engraved with texts that were likely to be read by visitors, as in this example. In addition to names and titles, they often included an idealized biography, an appeal to the living,

or an invocatory prescription for ritual offerings to the gods. Their very presence made it possible to perpetuate the blessings to which they refer through the magical power of writing.

This statue belongs to the very first collection of Egyptian objects that would form the basis of the Louvre's collection. It exemplifies the then-prevalent idea of and taste for Egyptian art: solid and massive, using dark stones, and bearing finely engraved hieroglyphs. This taste derives from the finds made in Rome after the seventeenth century, which served to fix a particular conception of the art of this civilization in the common imagination.

MARC ETIENNE

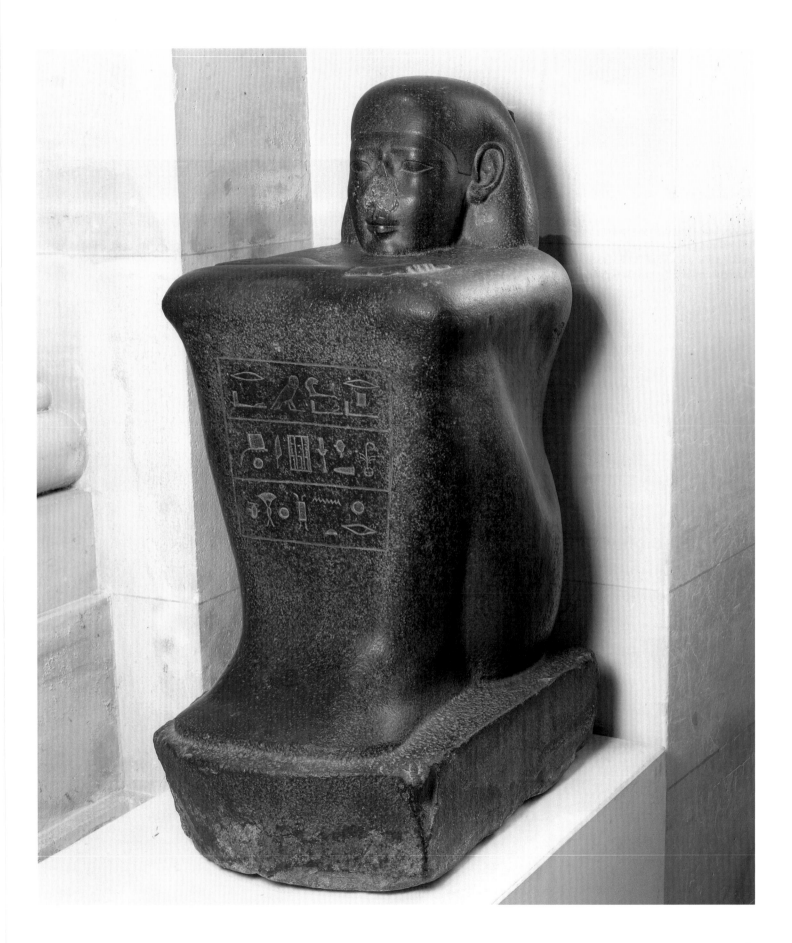

## 23
### *Capital decorated with head of the goddess Hathor*

Egypt, Ptolemaic Period, 332–30 BC
Limestone
20¹¹⁄₁₆ × 18⅛ × 4½ inches (52.5 × 46 × 11.5 cm)
Purchase, 1826, Salt collection
Department of Egyptian Antiquities, D 32, N 384

This fragment of a capital once decorated the top of a column that reproduced the image of a *sistrum* (a musical instrument similar to a rattle) on a monumental scale. This instrument was used in propitiary rites to the gods and especially goddesses. The upper portion of this instrument was decorated with an image of the goddess similar to this one: the face of a woman possessing the ears of a cow—an animal sacred to her—wearing a heavy wig decorated here with rosettes. The decorative fragments remaining on the sections suggest that all four sides of the capital originally featured a similar decoration. These types of pillars, called Hathor pillars, began appearing during the Middle Kingdom, around 2160 BC, and were employed until the Roman era. Their use was strictly limited to structures specific to goddesses.

During the Egyptian expedition, scholars were particularly impressed by the large temple of Denderah, a major sanctuary of the goddess Hathor, whose great columned hall was decorated with this type of capital. The publication of Vivant Denon's *Journey to Egypt and Nubia,* followed by that of *A Description of Egypt,* contributed to a wide diffusion of this motif, which became one of the most often repeated in the objects produced during egyptomania—the craze for all things Egyptian in the first quarter of the nineteenth century.

MARC ETIENNE

## 24
*Fragment of a royal decree*

Egypt, Ptolemaic Period, reign of Ptolemy II Philadelphus, 264–263 BC
Diorite
24½ × 16 inches (62.2 × 40.6 cm)
Purchase, 1808, Borghese collection
Department of Egyptian Antiquities, C 123

This fragment belonged to a monumental stele comprising a royal decree whose beginning and end are missing here, but whose content can be reconstructed thanks to other scattered fragments. The text is part of a series of decrees issued by the Macedonian kings of the Ptolemaic Dynasty in support of the Egyptian clergy. The decrees were reproduced on stelae, sometimes in several copies, such as the famous Rosetta Stone in the British Museum in London.

The example here is a decree issued by Ptolemy II Philadelphus in support of the priests of the city of Sais in the twenty-second year of his reign, the third month of the flood season, possibly on a date ranging between 27 December 264 and 25 January 263 BC. The opening lines are a long eulogy to the king, followed by the official text. The king was convening in Alexandria representatives of all the temples of Egypt—for an unspecified reason—including priests from the city of Sais. In his decree, he orders the Sais priests to make a procession of the statue of his sister and deified wife Arsinoe (II) alongside the other gods of the main temple.

We have been able to retrace the extraordinary history of this monument. Under the reign of Caligula (37–41 AD), who put an end to the ban against Egyptian worship in Rome, this stele was transported from Egypt to Rome to complete the decoration of a building dedicated to the ruling imperial couple, Caligula and his sister Drusilla, following the Ptolemaic tradition of worshipping rulers as gods. This building was in the famous Gardens of Sallust in Rome. The stele was subsequently broken. Fragments reproducing other portions of this text were found and copied in the sixteenth century in Rome and in the seventeenth century in Bologna.

The fragment in the Louvre belongs to a category of inscription fragments that were collected at the end of the eighteenth century as curios for the beauty of the as-yet-undeciphered hieroglyphs. The irregularly contoured slab was completed in a restoration of the original hieroglyphs, carved here more faintly, in keeping with the style of the authentic inscription.

MARC ETIENNE

## 25
### Mummy mask of a man

Egypt, Roman period, late 2nd–early 3rd century AD
Painted stucco
13³⁄₁₆ × 7⁵⁄₁₆ inches (33.5 × 18.4 cm)
Khargeh Oasis
Acquired in 1892, purchase
Department of Egyptian Antiquities, AF 2126

Masks of this type are the distant relatives of those placed over the heads of mummies during the pharaonic period, the best-known and most opulent example of which remains the golden mask of Tutankhamen in Cairo's Egyptian Museum. In this example, the only remaining Egyptian elements are the type of object and the iconography of the vignette found on the garment: the deceased is lying on a funerary bed, mourned by two kneeling figures, weeping, arms raised across their foreheads. The treatment of the face, however, reveals the influence of Roman art, with its curly beard and hair and the precise rendering of the facial features. As with all earlier examples, this mask was intended to render the face of the deceased divine by assimilating each of the features of his face with those of a divinity. In this way, the deceased would be recognized by the gods as one of their own. Although this man is rendered in a Roman fashion, he chose to be buried according to Egyptian funerary custom and not to be cremated according to Roman practice. It is not known whether he was a Roman citizen or an Egyptian native.

Following the defeat of Cleopatra and Mark Antony at Actium, Egypt fell under Roman rule. This mask presents a striking example of the juxtaposition of Roman taste with traditional pharaonic Egyptian culture that lasted until the sixth century AD.

**MARC ETIENNE**

# Excavating the Cradle
of Civilization

# Near Eastern Antiquities

*Béatrice André-Salvini*

*It was there, in the desert, that I first experienced it, that deep, dark sense visiting a ruin awakens, in those who know or suspect its sublime and tragic secret . . .*
*This earth covered with debris whose weathered splendor has but altered its beauty . . .*
*This earth covering up over fifty centuries of archived history yet still intelligible to our soul! And the soaring silence over these noble spaces clearing way for the great voice of History to resound everywhere.*

—Jean-Vincent Scheil, Conference on his excavations
of Sippar in Mesopotamia, 1911

The Department of Near Eastern Antiquities houses collections that evoke historically or mythologically prestigious names: Sumer, Ashur, Babylon, Susa, Persepolis, Jerusalem, Phoenicia, Palmyra, Arabia and the Incense Road, and Carthage. The full list of these names is considerably longer, since the traditional and historical framework of our collections covers a period of time stretching from the eighth millennium BC to the early Islamic period, and a territory extending from the Mediterranean to Iran and from Anatolia to Yemen—a field we are looking to enlarge to include Central Asia.

This tradition, linked with the history of research, enabled the organization of the Near Eastern Antiquities collections into broad geographic and cultural regions: Ancient Mesopotamia between the Tigris and Euphrates, the Iranian world, Anatolia, and the Mediterranean Levant, including Cyprus.

This region of the world has been a particularly rich crucible, where radically differing peoples have lived at various points in history at peace and at war, and whose cultures and civilizations have always cross-pollinated, by force or by commercial and cultural contact.

Between the third and first millennia BC—particularly in the second millennium— these civilizations and this mélange of peoples between the Mediterranean Sea and Iran formed what could be called "the cuneiform world." Cuneiform is the complicated syllabic and ideographic Mesopotamian script (cat. 49) that was widely exported outside its country of origin through its literate class, its merchants, and its armies. The shared use of this writing established a basis for a common culture that each people developed according to its traditions and goals. Widespread in the first millennium BC, the alphabet slowly and partially receded not long before the beginning of the modern era.

## EXCAVATIONS AND THE CREATION OF THE COLLECTIONS

It is the breadth and rich diversity of the collections, encompassing more than 100,000 objects, that gives the Louvre's Department of Near Eastern Antiquities a particular prestige among the great museums of the world and makes possible an installation based on a historical and chronological approach. This is the only suitable way to create links between the civilizations represented and lend coherence to this extraordinary cultural inheritance. Even in the creation of its collections, this department presents an originality distinct from other departments of the Louvre. Since its inception, the department has been associated with archaeological research, which was the very reason for its creation in the first place. That is why all types of cultural evidence uncovered by the excavations are presented—from artistic masterpieces to the most mundane utilitarian objects.

France was a pioneer in the field of archaeology in the nineteenth century through its diplomats and scholars dispatched to the Ottoman and Persian Empires. The desire to explore the Holy Land and all the places mentioned in the Bible and in the accounts of classical writers provided the impetus for their rediscovery and the birth of our collections.

Regulations and bilateral agreements on antiquities were set in place in the Ottoman Empire and in Persia during the second half of the nineteenth century, establishing ways for sharing rediscovered antiquities. In the countries that resulted from the reorganization of the Ottoman Empire after 1918, sharing continued up to World War II under French and English mandates. In Iran, this rule was maintained up to 1973. Nevertheless, the last objects from French excavations coming into the Louvre under this agreement came from the site at Meskene-Emar in Syria, in an excavation led by Jean-Claude Margueron between 1972 and 1976 that revealed a unique civilization from the thirteenth century BC. Within the framework of the Campaign to Protect the Antiquities of the Euphrates, the Syrian government has under special circumstances authorized the sharing of material found by foreign expeditions within the flood zone. France's allotment entered the Louvre in 1980.

Fig. 1. Human-shaped statue, excavations of 'Ain Ghazal, Jordan, ca. 7000 BC, gypsum plaster, 41⁵⁄₁₆ inches tall, DAO 96. Loan from the Directorate for Antiquities of Jordan, 1997.

The collections also increased through donations and purchases of pieces conserved in private collections or that had appeared in the past on the antiquities market, making it possible to supplement series and to create new ones, in hopes of regrouping examples from all the cultural provinces of the Ancient Near East.

Today, the troubled situation in the Middle East is affecting our ability to acquire new objects. The recent looting resulting from a difficult international situation has made it practically impossible to make any acquisitions on the antiquities market. It is thus important to advance a policy of exchanges between the major museums. A policy of loans or in-trust guardianships of works to the Louvre with the countries of the Near East seems to be the most satisfactory policy to take, provided it is made within the framework of a bilateral cooperation agreement, since they alone stand to benefit from any finds from recent excavations. In order to preserve the department's encyclopedic value—essential for teaching and research—acquisition should aim to fill in gaps and round out series, the study of which is all the more interesting with varied documents, and to enrich the presentation of the galleries devoted to status objects of historical importance.

It was within this framework that an agreement with the government of Jordan cleared the way for the long-term trusteeship of a gypsum plaster statue (fig. 1) dating from around 7000 BC, found during the excavations at the 'Ain Ghazal site, which entered the department in 1997. It is the oldest major work in the Louvre today. Beyond its archaeological interest, this piece is the first example of this new acquisition policy within the framework of cooperation.

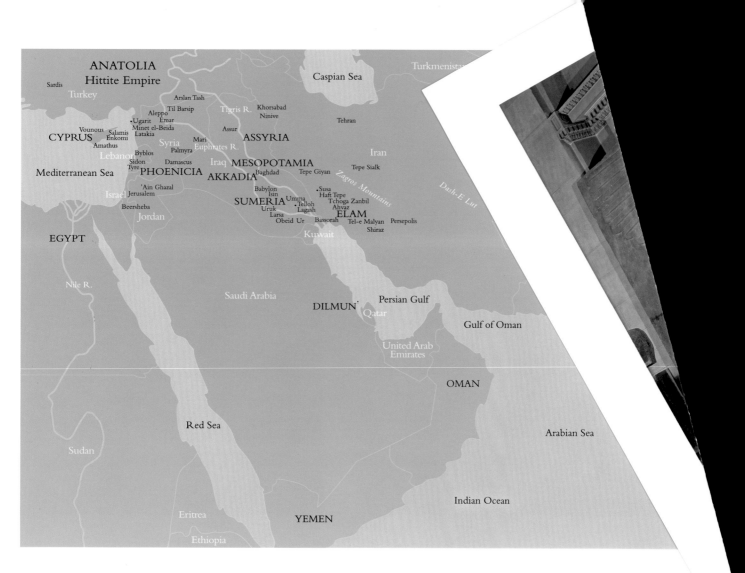

**THE COLLECTIONS**

*Mesopotamia: Between the Tigris and Euphrates*

It was on the lands of modern-day Iraq that the first archaeological explorations in the Near East took place, since scholarly circles in the West were aware that the cradle of our civilizations would be found there.

**Assyria**

The kings of Assyria were the first rulers from the Ancient Near East to have resurfaced to history thanks to their romantic rediscovery in 1842 by the French Consul in Mosul, Paul-Emile Botta, who was the modern discoverer of this lost northern Mesopotamian civilization. Up to that point, the renown of the Assyrians came to us solely through indirect sources of information—principally from the Bible, Greek and Latin authors, and, to a lesser extent, from medieval Arab historians and geographers. These sources provided a synopsis of historical facts about rulers who would become figures of legend, geographical or topographical data—principally on the location of the city of Nineveh, the ultimate center of their power—and a general sense of the societal order of Assyrian civilization, wherein fiction and fact merged. Lastly, western travelers from the Middle Ages to the modern era have left us stories, drawings of objects, and strange scripts, samples of which they brought back with them, helping to revive the memory of this antiquity and making the idea of digging up ruins of this civilization conceivable.

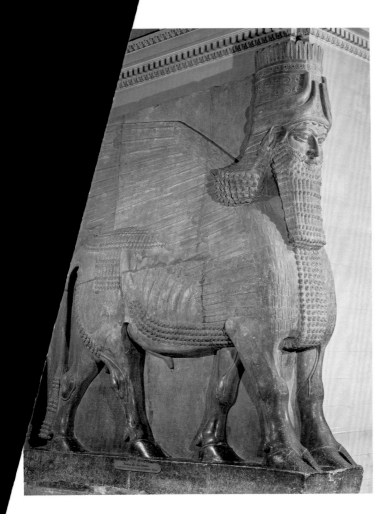

Fig 2. Winged and human-headed bull guard for the gate of the palace of Sargon II of Assyria (721–705 BC), Khorsabad, ancient Dur-Sharrukên (Iraq, area of Mosul), gypsum alabaster, 13 feet 9¼ inches high, Musée du Louvre, Department of Near Eastern Antiquities, AO 19857.

Fig. 3. Sargon II and the crown prince Sennacherib, flagstone decorated with bas-relief, covering the bottom of the walls of the palace of Sargon II at Khorsabad, late 8th century BC, gypseous alabaster with traces of polychrome, 10 feet 11 inches high, Musée du Louvre, Department of Near Eastern Antiquities, AO 19873, AO 19874.

Botta excavated the ruins of Nineveh and those of the Palace of Khorsabad, the ancient Dur-Sharrukên, capital of the conqueror of Samaria, King Sargon II (721–705 BC). Botta ruined his health there, spending long hours copying inscriptions engraved on slabstones that would turn out to be the historical annals of the kings of Assyria. His work furnished the basic documentation for deciphering cuneiform scripts. The monumental bas-reliefs (figs. 2 and 3) brought back to France illustrating this people's history and beliefs made possible the creation of the first Assyrian Museum (*Musée Assyrien*), inaugurated at the Louvre in 1847 and thereafter rejoined with the Department of Antiquities (Département des Antiques). Thanks to his successor, Victor Place, who returned to Khorsabad some years later, and to the intense activity of France and England, portraits, texts, and images of the deeds of kings maligned by the Bible were gradually brought back to light, taking their proper place at the Louvre and the British Museum. Among these kings were Sennacherib (704–681 BC) and his grandson, Ashurbanipal (668–627 BC), known more for his warlike cruelty than for his personality as an enlightened king, though it was he who established the first universal library at his palace at Nineveh, more than four centuries before that of Alexandria.

## Sumer

Thirty years later, the discoveries made by another French Consul in the southern area of Basra would mark an important date in our knowledge of Mesopotamian history and would make the Louvre the first conservatory for the world's oldest literate civilization, having preceded that of Ashur by two thousand years. It was in 1877 that Ernest de Sarzec, during a prospecting trip, noticed a fragment of a statue sticking out of a mound of ruins. He undertook archaeological excavations in this arid place called Telloh (see page 110), unearthing the ruins of an ancient city. Significant vestiges of large statuary and other sculpted fragments quickly came to light, many bearing long inscriptions in cuneiform script, with signs more archaic than those discovered at the excavations of ancient Assyria or Persia. The language was unknown, but its eventual deciphering revealed that it was from a civilization lost to human memory for thousands of years—that of the Sumerians, the probable inventors of writing (fig. 4).

Since 1879, archaeological research has been conducted in accord with and supported by the Assistant Director of Antiquities at the Louvre. In the same year, a concession for excavations was accorded to France by the Ottoman Empire. Twenty archaeological campaigns were conducted up to 1933. The arrival in France of the first Sumerian antiquities from Telloh in 1881—notably the somber dolerite statues representing Prince Gudea of ancient Lagash (see page 116 and cat. 44)—led to the creation of the Louvre's Department of Near Eastern Antiquities.

The Mesopotamian section gradually grew in the first half of the twentieth century thanks to French excavations, particularly those conducted by the Assyriologist François Thureau-Dangin in the eighth-century BC provincial Assyrian palace of Til Barsip/Tell Ahmar in eastern Syria, which yielded richly colored painted murals (fig. 5). His investigations at Arslan Tash, capital of the kingdom of Northern Syria, subsequently annexed to Assyria, found stelae in a variety of styles—showing a mélange of Syrian and Assyrian influences—and ivories that had embellished royal furniture. The most important contribution, however, came from the excavations conducted by André Parrot who, beginning in 1933, brought to light kingdoms that had been independent before being swallowed up by the Babylonian Empire of King Hammurabi

Fig. 4. Protocuneiform accounting tablet, ca. 3000 BC, Lower Mesopotamia (Iraq), clay, 1 13/16 × 1 7/8 inches, Musée du Louvre, Department of Near Eastern Antiquities, AO 8856.

Fig. 5. "The blue goat," 8th century BC, Tell Ahmar, ancient Til Barsip, Assyrian palace (Syria), mural painting; 20 1/8 inches high, AO 23010.

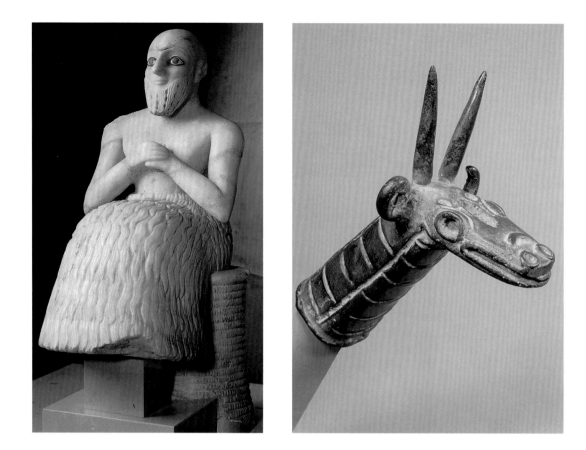

(1792–1750 BC). Among these kingdoms were Larsa, an ancient capital of the Land of Sumer, and principally Mari, a city from the Syrian Middle Euphrates, the seat of dynasties (fig. 6) that provided the link between the civilizations of Mesopotamia and the Levant in the third and early second millennia, before its destruction by Babylonian troops in 1760 BC. The French excavations at the site are still active to this day.

**Babylon**

Babylon had never been forgotten, because of its incomparable prestige and because the location of its ruins was known as a frightening place. According to old legends, it was said to be peopled by djinns and dragons, in an echo of the horned snake-dragon, the emblem of the god Marduk (fig. 7), whose figure endlessly decorates Babylonian murals in the time of the great King Nebuchadnezzar II (605–562 BC), the conqueror of Jerusalem, damned by history for carrying the Jews into captivity. Nonetheless, he made his capital the cosmic center of the world thanks to the might of Marduk, in whose name all divine powers coalesced, before it passed into legend under the name of Babel.

Babylon entered the Louvre by way of its royal origins, with the Code of Hammurabi (fig. 8)—the most famous monument from Mesopotamian antiquity and one of the Louvre's masterpieces—but also thanks to a strange twist of history. The high basalt stele that has given us the portrait of the king—shown receiving from the Sun the powers to assume responsibility for meting out justice, as set forth at length in the text covering the monument—was discovered not in Babylonia, but at the site of Susa, situated on the Iranian arm of the Mesopotamian plain (see page 88).

Hammurabi was the "king of justice" who 3,800 years ago turned Babylon into a pinnacle of culture, whose literature and scientific knowledge (such as astronomy, mathematics, and divination) would radiate throughout the ancient world. This Babylonian literature, coming to us in the form of fragile clay tablets, comprises creation myths, wisdom literature, chronicles, and dictionaries. These texts were diffused and recopied by master scribes throughout the Near East, forming the basis of a common literary source that would be replaced in form and revised by the authors of the Bible, just as Homer may well have been inspired by the hymns and epic tales of Babylon. The *Epic of Gilgamesh*, the story of the semi-mythical king of the city of Uruk, the first versions of which appeared in the third millennium BC, heralded the exploits of the Greek hero Herakles (or Roman Hercules).

The Code of Hammurabi (fig. 8) constitutes the most important legal compendium from the Ancient Near East, predating the biblical laws. Initiator of the "law of talion," it is moreover an exceptional source for our knowledge of the society, religion, economy, and the event-driven history of this time. It deals with subjects covering civil and penal law. The most important chapters concern the family, slavery, and professional, commercial, agricultural, and administrative law. The stele presents an image of power, a record of a prestigious reign, and a political testament aimed at future princes, for whom it offered a model of wisdom and equity.

> Just decisions which Hammurabi, the wise king, has established. A righteous truth, and correct way of life did he teach the land. . . . [L]et the oppressed, who has a case at law, come and stand before my image as king of justice; let him have my inscribed stela read to him; and may he hear my precious pronouncements: my stela will explain his case to him; he will find his case, and his (troubled) heart will be calm. . . . I am Hammurabi, king of justice, to whom Shamash has granted the truth. (Epilogue, *Codex Hammurabi*)

Brought from Babylonia by a prince from the neighboring country of Elam in Iran in the twelfth century BC, the monument was displayed on the Susa acropolis among other Mesopotamian masterpieces, gathered by a prince wishing to associate himself with a prestigious past and to turn Susa into a major center of Mesopotamian tradition. By exhibiting these war trophies next to Susian monuments, he was making a connection between himself and heroes of the past. It was there that the pioneers of the French archaeological mission to Susa discovered all the great Mesopotamian sculpture that made the Louvre the conservatory of Akkadia, Sumeria, and Babylon.

Fig. 8. The Code of Hammurabi, ca. 1760 BC, Susa (Iran, taken from Babylonia), black basalt, 7 feet 4¼ inches high, Musée du Louvre, Department of Near Eastern Antiquities, Sb 8.

## Iran

Ancient Iran is represented at the Louvre thanks to the excavations of the metropolis of Susa, founded circa 4000 BC (see page 88). Our collections cover its entire history, culminating with the great kings of the Persian Empire, Darius and Xerxes. The décor of their palace, built around 500 BC, adorns the Louvre galleries, placing them under the protection of the "Immortals," the archers (cat. 39) making up the personal guard of the kings. According to Herodotus, Susa was "*where the great king has his residence, and where are the store-houses of his wealth. Take this city, and then you need not fear to challenge Zeus in the matter of wealth*" (*Histories* V, 49). Susa was spared by Alexander the Great because of its legendary antiquity. Susa was where the Bible situates the banquet of King Ahasuerus in honor of his wife, Queen Esther, in a gold and silver ceremonial plate like those on exhibit at the Louvre or the National Museum of Iran (Tehran).

It was Marcel Dieulafoy who, in search of the sources of western culture, explored this palace in 1885–1886 and brought back to the Louvre the first decorative elements, first exhibited in 1887. His work at Susa was continued by the French delegation in Persia, created in 1897 by Jacques de Morgan, and was pursued right up to the eve of the Iraq-Iran War in 1979. The palace walls were covered with an opulent polychrome decoration of enameled bricks, inspired by those of the palace of King Nebuchadnezzar II in Babylon. The chronicler of the *Univers Illustré* recounts the astonishment of the Paris crowds in discovering these masterpieces after the conference Dieulafoy led on the results of his excavations in Persia, a few days after the inauguration of the Louvre's Achaemenid antiquities rooms (see fig. 9), on the night of 27 June 1887:

Fig. 9. Engraving from *L'Univers Illustré,* showing the public herding into the Louvre's newly inaugurated Persian galleries on 27 June 1887.

The Louvre's new galleries . . . were soon full of a curious and engaged crowd. Many had never seen this superb collection that once again brings to life a faraway civiliza-tion celebrated for its brilliance and power. . . . The group circulated around these wall fragments embellished with faded color decorations, life-size animals and people shown in bas-reliefs with the superb costumes of their time. The enamels from which such colors were recovered excited curiosity and sparked interesting comments. The colossal two-headed capital at the back of the room attracted the greatest attention from the visitors.

Our collection of objects from Susa and other areas of Iran has been enriched by the fruit of French excavations beginning in 1931 and ending around 1970, thanks largely to the explora-tion of sites from the Iranian Plateau—Tepe Giyan and Tepe Sialk—by Roman Ghirshman, who also explored the royal city of Tchoga Zanbil, near Susa, from 1947 to 1967. Various gifts have made it possible for the department to also acquire collections from Northern Iran.

Lastly, the Near Eastern Antiquities Department houses a series of historical plaster casts executed in the nineteenth century that reproduce monuments from open-air archaeological sites spread out across the terrain of Iran as well as Iraq, and casts of stone inscriptions which made the success of the first decipherers of cuneiform scripts possible.

Fig. 10. Sarcophagus of
Eshmunazor II, king of Sidon,
5th century BC, Sidon
(Lebanon), black amphibolite,
8 feet 4¾ inches long, Musée
du Louvre, Department of Near
Eastern Antiquities, AO 4806.

## The Levant
The creation of our collections from the Levant—Syria-Phoenicia, Palestine, Cyprus, and Anatolia—has an equally ancient origin.

### Syria and Lebanon (Phoenicia)
In 1860 France was brought in to mediate in the Levant for the protection of holy sites. The military mission sent by Emperor Napoleon III was accompanied by an archaeological mission led by the orientalist Ernest Renan. He explored numerous sites where he discovered a large collection of Phoenician antiquities. During the course of his journey, Renan gathered material for his monumental *Mission de Phénicie,* published from 1864 to 1874, and he sent monuments and objects back to the Louvre that would form the nucleus of its Phoenician collection. They consist of pieces mainly from Byblos, Tyr, and Sidon, from which most notably came a large series of sarcophagi. The lengthy inscription on the sarcophagus of King Eshmunazor II of

Sidon (fig. 10), brought back by the Duke de Luynes in 1855, advanced our understanding of the Phoenician language—it tells the sad story of this young ruler: "*I was taken before my time, so young, an orphan, and a widow's son.*"

The goal of these missions was highly scientific, the nature of which formed the principle guiding the choice of the antiquities sent to the Louvre: "In focusing on the museum pieces, we have avoided turning our attention away from the major historical problems. . . . France has maintained the wise principle that the purpose of scientific journeys is not to serve the vain curiosity of the public, but to advance science." (E. Renan, *Mission de Phénicie* [Paris, 1864], p. 815)

In 1846, Pierre de Ségur-Dupeyron, French Consul in Damascus, had brought back two funerary heads from the site of Palmyra in the Syrian desert, fatherland of Queen Zenobia (ca. 240 BC). These were the first antiquities from Palmyra to enter the Louvre.

Following World War I, France, then the mandated power in Syria, organized the unearthing and conservation of monuments, exciting great archaeological interest. From the site of Ras Shamra, the capital of ancient Ugarit on the Syrian coast—excavated beginning in 1929 by the French mission led by Claude Schaeffer—the Louvre received shared allotments of prestigious monuments up to 1939 (see page 130). This site, like that of Mari on the Euphrates, continues to be excavated by a French mission.

## Palestine

In Palestine, the mid-nineteenth century saw Félicien de Saulcy explore the "Tomb of the Kings" in Jerusalem. After the Duke de Luynes, Charles Clermont-Ganneau, the French Consul in Jerusalem, launched a period of active research and study. In 1873, he recovered a text on a basalt stele with a squeeze (a papier-mâché impression), then purchased the broken fragments of the stele for the Louvre, which recounts the victory of Mesha, King of Moab, over the kingdom of Israel, after the death of Achab in the ninth century BC, thereby providing us with a complementary and competing account of a battle recorded in the biblical Book of Kings.

In Israel, excavations undertaken after World War II by Jean Perrot at the site of Beersheba in the Negev reveal a pastoral civilization dating back to the mid-third millennium BC. Everyday objects from Tell el-Far'ah are the fruit of excavations led by Father Roland de Vaux of the French Biblical and Archaeological School of Jerusalem; they date back to the Israelite monarchy, since this name was formerly that of ancient Tirzah, the first capital of the north after the division following the death of King Solomon in the tenth century BC. Gifts and trust loans from the Department of Antiquities of Israel continue to round out the collections.

## Cyprus

The Marquis Melchior de Vogüé, on expedition in Cyprus in 1862 and 1864, returned with the first collections of Cypriot antiquities, including the monumental stone vase of Amathus (fig. 11), which was erected on the Acropolis in front of the Temple of Aphrodite (seventh–fourth century BC). The majority of the Louvre's significant collection of Cypriot antiquities come from excavations led by Claude Schaeffer in the Vounous Necropolis, dated around 2300 BC, and on the port site of Enkomi, near Salamis, the contents of whose tombs illustrate the port's prosperity in the thirteenth and twelfth centuries BC.

Fig. 11. The vase from
Amathus in front of the
Temple of Aphrodite in
Cyprus, nineteenth-century
engraving.

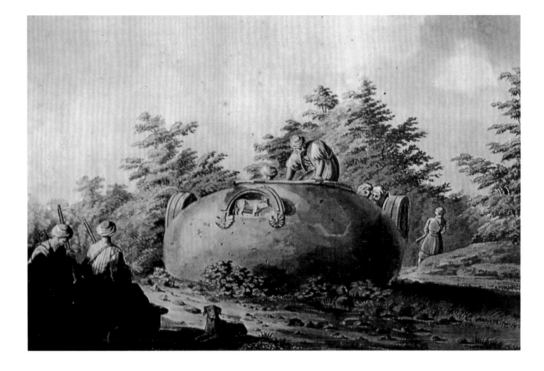

## Anatolia, Arabia, and Northern Africa

The missions completed by Ernest Chantre in 1892 and 1894 brought a series of Anatolian antiquities to the Louvre, which were supplemented through gifts and acquisitions from select collections during the late nineteenth and early twentieth centuries. This was much the same case for the large Punic and South Arabian collections, which also benefited from trust loans of collections from the Bibliothèque Nationale de France and from the Académie des Inscriptions et Belles-Lettres.

The galleries of Near Eastern Antiquities in the Louvre can seem complex and difficult to the layman, but the story unfolds in step with the history of the part of the world that was the cradle of the civilizations to which we are the heirs.

Cooperation with the countries of origin of our collections is currently being pursued and developed at a pace determined by the political situation in this area of the world. This situation will also lead us on to new or little-developed horizons, allowing us to extend the department's geographical and historical fields, notably in Central Asia (Turkmenistan). The international cooperation programs the department is pursuing today involve nearly all the countries in the Middle East.

Research is also being done in close association with the major national and international bodies working in our fields through expositions and publications relating to our collections. The complexity of establishing these involves a specific and well-developed interest in the history of the collections, which is taking shape as a principal axis for the department's research for the years to come.

# Susa, Capital of Elam

*Agnès Benoit*

## A DOUBLE IDENTITY

The city of Susa is the principal site of reference for ancient Iran. It is the only city to have known a period of continuous occupation for 6,000 years, from its creation in 4200 BC until the thirteenth century of the modern era. It has revealed the Elamite civilization that developed in Iran well before the Persians built their vast empire. In the late fourth millennium BC, this culture stepped forward into history through its use of an indigenous script called Proto-Elamite, which later was replaced by the cuneiform characters of the Sumerians. Set in the small Susian plain irrigated by the Karun and Kerkha rivers that extends the Mesopotamian plain to the east, during the course of its history Susa demonstrated both a vulnerability to Mesopotamian influence from the west and a uniquely Elamite originality, deeply rooted in the mountainous region to the south. Its geographical position played a determining role in the expression of this double culture: the seasonal movements of population related to herd migration, very common in a pastoral economy, established permanent contacts between the lowlands and highlands of Elam (a political entity extending to the Western part of pre-indo-European Iran), between regions of Susiana and Fars, with two capitals at each end: Susa in the plain (about 45 miles from Ahvaz, today a major oil-producing city) and Tell-e Malyan/Anshan in the mountains (about 45 miles from modern-day Shiraz).

## EXCAVATION TIMELINE

The excavations conducted at Susa (fig. 1) were primarily French and were performed on the three tells (mounds) of the agglomeration: the Apadana mound to the north, named for having contained the Persian palace built around 521 BC by Darius the Great; the Acropolis mound to the west, which dominated the plain with its 125 feet of archaeological deposits; and lastly, to the east, the large Royal City mound that extended to the south in an annex called the Donjon.

The excavations began in 1884 with the investigation of the palace of Darius by Marcel Dieulafoy, accompanied by his eccentric wife, Jane—veritable adventurers—who returned to France with the first Archers (see cat. 39), several lions from the Lions Frieze, and the great capital of the Apadana, an old Persian term used to designate the audience hall at the palace of Darius. The site was closed in 1979 when the Islamic revolution put an end to the mission directed by Jean Perrot, whose principal objective had been to clarify the periodization of a site sometimes too hastily excavated by the teams that had preceded him. The two conventions signed in 1895 and 1900 between the French authorities and two successive Shahs, Nasir-ud-Din and Mazaffar-ud-Din, accorded great privileges to France. These have made it possible today for the Musée du Louvre to display not only examples from Elam but also numerous Babylonian masterpieces that were removed in the twelfth century BC by the Middle Elamite King Shutruk-Nahhunte, who decorated his capital with the spoils of war from his conquests in Mesopotamia. It is thanks to this ruler and to the work of the French delegation in Persia led by Jacques de Morgan from 1897 to 1912 that the Louvre has been able to list in its Susian inventory monuments of such importance as the masterpieces celebrating the Akkadian kings—stelae of Sargon, statues of Manishtusu, the victory stele of Naram-Sin—as well as the Law Code of King Hammurabi, the fifth representative of the first Babylonian dynasty, and the Kassite kudurrus. Made wary by missteps with the English at the Assyrian field sites, notably at Nineveh, France had sought to obtain privileged archaeological rights in Susiana and even in Persia.

## PHASES OF OCCUPATION AT THE SITE

### Origins of Susa

Susa was created around 4200 BC in the western region of Iran, on a plain now called Khuzistan, though it is commonly

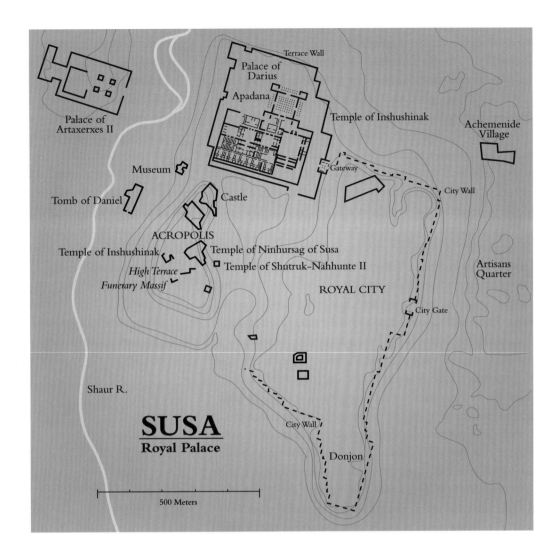

The following labels appear on the map:

Palace of Artaxerxes II

Palace of Darius
Terrace Wall
Apadana
Temple of Inshushinak
Achemenide Village

Museum

Tomb of Daniel
Castle
Gateway
City Wall

ACROPOLIS

Temple of Inshushinak
Temple of Ninhursag of Susa
Temple of Shutruk-Nahhunte II

High Terrace
Funerary Massif

ROYAL CITY

Artisans Quarter

City Gate

Shaur R.

**SUSA**
Royal Palace

City Wall
Donjon

500 Meters

Fig. 1. Map of the excavations at Susa, 1884–1979. E. Carter and M. W. Stolper, *Elam, Surveys of Political History and Archaeology* (University of California: Berkeley and Los Angeles, 1984).

referred to by archaeologists as the Susian Plain, after the name of the site in the Chaour Valley. The period from 4200 to 3800 BC is stratigraphically designated as Susa I. The surface area of the earliest agglomeration is estimated to be nearly twenty-five acres, excluding an extension on the Apadana mound. Initially, it was a group of villages dominated by a solid mass of masonry built over the acropolis mound, whose purpose appears to have been funerary. A necropolis soon formed around the funerary massif, from which nearly 2,000 tombs were excavated by the Delegation in Persia. These tombs have provided the most exquisite pieces of painted ceramics, some examples of which are seen in this exhibition.

Near this same massif was built a vast multilevel terrace, whose southern façade (the only one recognizable) was more than 250 feet long and must have been at least thirty feet high. This represents a structure considerably larger than those from either the late Neolithic or Ubaid periods. Its finely made walls were decorated with clay nails arranged in parallel bands of four. Such a monument would have undoubtedly

been the administrative and religious center of the agglomeration, which raises a question: Did Susa during the Susa I period already meet the criteria defining a city? The sheer scale of the work necessary for constructing the high terrace is a sure indication of an organized and hierarchical society. This is confirmed by the selective distribution of the metal objects in the tombs, since only seventy of the excavated tombs yielded mirrors or flat copper axes. The presence of an authority figure in the glyptic shown as a character wearing a robe with zigzag patterns and wearing an ovoid headdress also serves to support this interpretation. However, the overall administration seems to be little developed, since accounting tools are absent and the decoration of the vases and pottery and on the seals still roots the agglomeration in the prehistoric world. These seals are circular or square tablets, engraved to leave a relief mark on the medium on which they were stamped. Their iconography is akin to that of Lorestan, and aligns them with a far-flung group that prohibited human representation, except when showing an animal trainer spirit,

## Late Third and Early Second Millennium

At the close of the third millennium Susa regained its autonomy with the last representative of the Awan Dynasty, Puzur-Inshushinak, a contemporary of the Neo-Sumerian rulers Gudea and Ur-Nammu. During his reign, the king commissioned large-scale limestone statuary to decorate the temple of the Susian tutelary god, Inshushinak.

The two scripts engraved on monuments from this period were Akkadian cuneiform and linear Elamite, a completely new and indigenous script that remains undeciphered. Appearing in the Lut Desert and on a vessel from the Marvdasht Plains in the Fars region, it must have been exported to Susiana around 2150 BC.

For a while, Puzur-Inshushinak controlled the Diyala Valley, the Tigris tributary closest to the Persian Gulf, but in all likelihood he was subjugated by the second king of the third dynasty of Ur, Shulgi, who was anxious to control an access point to the tin routes from the East. To underscore his domination of Susa, Shulgi had two temples built dedicated to two major patron divinities: Inshushinak, the god of the Susian Plain, and the Sumerian goddess Ninhursag. These buildings made from unbaked brick—mis-identified by initial excavations—are attested to by sixteen foundation nails representing a prince carrying on his head a hod of building bricks

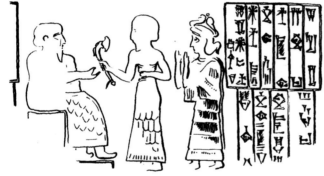

Fig. 3. Seal imprint of Kuk Simut, chancellor to Idaddu II, king of Simashki, Susa, end of the 3rd millennium BC, argile, and drawing of the design, inspired by Neo-Sumerian glyptic art, Musée du Louvre, Department of Near Eastern Antiquities, Sb 2294.

Fig. 4. Hammer with an elongated collar in the shape of bird's plumage and inscribed to Shulgi, Anshan and Susa, end of the 3rd millennium BC, bronze, 4⅞ × 4⁵⁄₁₆ inches (12.3 × 11 cm), Musée du Louvre, Department of Near Eastern Antiquities, Sb 5634.

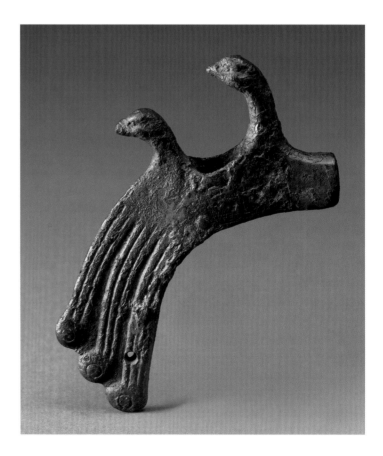

for the temples, engraved with an inscription of the names of the commissioner and the divinity.

At the very end of the third millennium, the rulers of the lands of Simashki regrouped into a league of many principalities and led a rebellion against the third dynasty of Ur by allying themselves with the Amorites, a nomadic people who had begun to infiltrate the urban world. Idaddu I, son of the conqueror of Ur, set himself up in Susa by keeping the title King of Simashki and Elam. These rulers maintained a custom of decorating high-ranking dignitaries with tokens of honor in the form of ceremonial hammers or axes in recognition of their worth. This ceremony is illustrated in the seal imprint of Kuk Simut, chancellor to the king of Simashki, Idaddu II (fig. 3), in a scene of meeting between the king and the civil servant, accompanied by a Lama goddess, inspired by Neo-Sumerian glyptic art. This custom was practiced elsewhere in Iran in this period, as shown by a hammer found in Susa with an elongated collar in the shape of bird's plumage and inscribed to Shulgi (fig. 4).

The well-to-do bourgeoisie around 2000 BC had themselves buried in terracotta sarcophagi in the shape of upside-down bathtubs (fig. 5), surrounded by highly original furnishings of bitumen crockery, notably bowls decorated with goats or bovids on the front face (fig. 6).

Around 1970 BC, the dynasty of the sukkalmahs—Grand Regents, a title equivalent to that of the emperor of Elam—took over the Simashki dynasty, of which it had been an offshoot. The Ebarat/Eparti rulers adopted the title of King of Anshan and Susa and shared power according to tripartite co-regency. If the more important person was the King of Anshan and Susa, the second was the sukkalmah, or Grand Regent, and the third was the sukkal and ippir (magistrate) of Susa.

## Elamite Civilization at its Zenith

The history of the kingdom of Anzan and Susa (Anzan is now preferred over Anshan) during the Middle Elamite period was marked by two great dynasties: the Igihalkids in the fourteenth century BC and the Shutrukids of the twelfth century BC. Around 1500 BC, Susians had resumed the Shahdad practice of funerary statues. They would carry into the tomb an effigy of the deceased made of unbaked clay to perpetuate their living image. In the course of the fifteenth century BC, Susa seems to lose its importance, to the advantage of the city of Haft Tepe, ancient Kabnak, at the center of the Susian plain. This city is known not only for its two terraces and its workshops for the manufacture of heads of unbaked clay, but above all for its funerary temple that

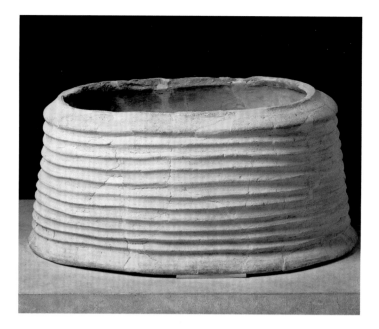

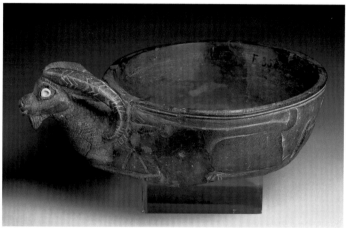

Fig. 5. Sarcophagus shaped like an upside-down bathtub, Anshan and Susa, ca. 2000 BC, terracotta, 23⅝ × 51³⁄₁₆ × 33½ inches (60 × 130 × 85 cm), Musée du Louvre, Department of Near Eastern Antiquities, Sb 20867.

Fig. 6. Bowl with a goat on the front face, Anshan and Susa, ca. 2000 BC, bitumen, 4⅝ × 11¾ × 8¼ inches (11.7 × 29.8 × 21 cm), Musée du Louvre, Department of Near Eastern Antiquities, Sb 2740.

The twelfth century was the most prosperous of the Middle Elamite period. It corresponds to the dynasty of the Shutrukids, primarily represented by the conquering king Shutruk-Nahhunte and by his two sons, Kutir-Nahhunte and Shilhak-Inshushinak. These rulers turned the newly reinaugurated capital into a conservatory of masterpieces. In essence, they repatriated monuments from Tchoga Zanbil and displayed the spoils of war looted from Babylon by the first representative of the dynasty. They also made it into a construction site for building temples. This was when the dynastic temple on the Apadana mound was built, with its decorated façade of bull-men figures associated with palm trees and Lama goddesses (cat. 38). From the reign of Shilhak-Inshushinak dates a unique model entitled the *Sit-Shamshi* (fig. 8), which depicts a sunrise ritual that gives a three-dimensional view of the cultural practices that could have taken place in front of the southeast façade of the ziggurat of Tchoga Zanbil (fig. 9).

During his war campaign against Babylonia, Kutir-Nahhunte seized the statue of Marduk, guardian god of Babylon. Nebuchadnezzar I, the energetic king of the new Isin dynasty, zealously set after recovering it and ravaged Susa in the late twelfth century BC. The power of the Elamites lapsed into obscurity for over three centuries.

## First Millennium
### Renaissance and Demise of Elam

The Neo-Elamite period has long remained the most obscure in the history of Elam. The resumption of the excavations at Susa in 1975 by the team of Jean Perrot on the site of the

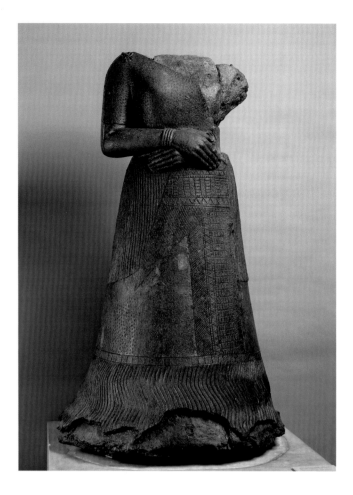

Fig. 7. Life-size statue of Queen Napirasu, wife of King Untash Napirisha, Anshan and Susa, ca. 1340–1300 BC, Middle Elamite period, bronze and copper, 50¾ × 30½ × 28 inches (129 × 77.5 × 71 cm), Musée du Louvre, Department of Near Eastern Antiquities, Sb 2731.

enclosed two vaulted tombs, similar to those at Susa. In one of them most likely rested the remains of King Tepti-Ahar, accompanied by a large entourage.

In the fourteenth century BC, King Untash Napirisha undertook the construction of a holy city twenty-five miles southeast of Susa. Occupying an area of 10,000 acres and subdivided by three enclosures, the agglomeration of Tchoga Zanbil was meant to be a center of pilgrimage and to gather all the worship cults of the kingdom around two principal gods: Napirisha representing the highlands and Inshushinak representing the lowlands. Susa was certainly forsaken at that time but it was to Susa that large masterpieces of metalwork were later conducted, such as the table decorated with snakes and the life-size statue of Queen Napirasu, wife of Untash Napirisha, an extraordinary casting with an astonishing bronze core, weighing nearly two tons (fig. 7).

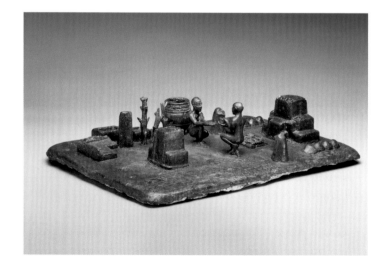

Fig. 8. Model entitled the *Sit-Shamshi,* Anshan and Susa, 12th century BC, Middle Elamite period, bronze, 23⅜ × 15¾ inches (60 × 40 cm), Musée du Louvre, Department of Near Eastern Antiquities, Sb 2743.

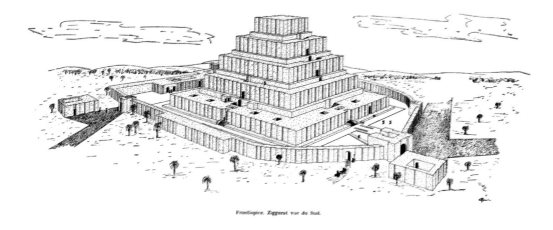

Frontispice: Ziggurat vue du Sud.

Fig. 9. The southeastern façade of the ziggurat of Tchoga Zanbil as it would have appeared in the 12th century BC.

Royal City II and new approaches to the deciphering of the texts made it possible to see more clearly. Beginning in the eighth century BC, the Elamite kingdom recovered some of its former vigor and Susa arose from its torpor in a kind of renaissance. The ancient monarchy of Anshan and Susa was restored, but in a less-centralized form than in the fourteenth–twelfth centuries. Three royal capitals seem to have co-existed: Susa, Madaktu—near where King Teuman, who had dared to oppose the great Assyrian king Ashurbanipal, was executed—and Hidalu, according to a tripartite reorganization that could pick up where that established by the Eparti/Ebarat in the early second millennium had left off.

Assyrian annals also reveal that King Ashurbanipal conducted several war campaigns in Elam. In two successive expeditions against Susa (in 653 and 646 BC), he sacked the city once and for all:

> Susa, the great holy city, abode of their Gods, seat of their mysteries, I conquered as commanded by Assur and Ishtar. . . . I destroyed the ziggurat of Susa that had been made of bricks of lapis lazuli; I smashed its shining copper horns. . . . Thirty-two royal statues cast in silver and gold or made of alabaster, I hauled back to the land of Assur. . . . I reduced the temples of Elam to naught; their gods and goddesses, I scattered to the winds. Their secret groves where no stranger had ever penetrated or set foot, my soldiers trespassed there, they saw their mysteries, they destroyed them by fire.

## Susa, Capital of the Achaemenid Empire

In the last quarter of the sixth century BC, King Darius I decided to empower the political and administrative officers of the empire bequeathed to him by Cyrus the Great and then Cambyses. He promoted carving the conquered territory into more than twenty satrapies, at the head of which he would establish two capitals out of respect for the two-headed tradition of Elam: Susa for the lowlands, Persepolis for the upper regions. In each of his capitals, Darius undertook the construction of palaces. At Susa, the construction work began shortly after his accession around 521 BC, and went on almost to the end of his reign. It was decided that it should be built on the northwest hill, known as the Apadana tell (mound). The ground was first prepared and an artificial terrace covering 1,500 acres was raised nearly fifty feet above the plain. With this palace, the monarch gave testament to his will to be written into tradition by adopting a Mesopotamian plan for the residential part, arranged into rectangular spaces around central courtyards, and by having the walls surfaced with colored decorations inspired by the palace of Babylon. It is certainly in this area that the famous Frieze of Archers (see cat. 39) was located. The Apadana, north of the residential area, measured 120 yards across and served a very different purpose: in this hypostyle porch area, the grandeur of the empire was rendered palpable by the majesty of the place, impressing the visitor with its thirty-six columns rising to the height of more than seventy-five feet. In the terrace areas not built upon, gardens were cultivated where exotic spices were grown, which, according to the Greeks, were beloved by the Persians. The destruction of the Persian empire by Alexander the Great marked the final death knell for Susa in its role as capital.

## 26
*Large beaker decorated with chevrons, reeds, and checkers*

Susa I, Proto-urban period, 4200–3800 BC
Painted terracotta
11¾ × 6½ inches (29.8 × 16.5 cm)
Excavations J. de Morgan, 1908–1909
Department of Near Eastern Antiquities, Sb 3173

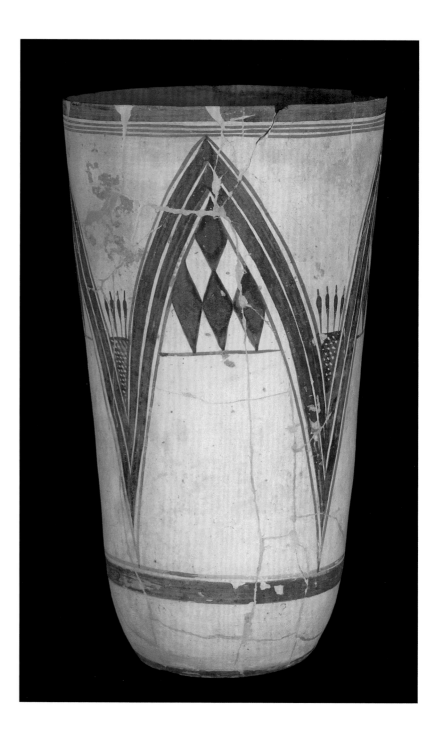

## 27

*Hemispheric bowl decorated with a central cross
and "comb-animals"*

Susa I, Proto-urban period, 4200–3800 BC
Painted terracotta
9⅞ inches (25.1 cm) in diameter
Excavations J. de Morgan
Department of Near Eastern Antiquities, Sb 3201

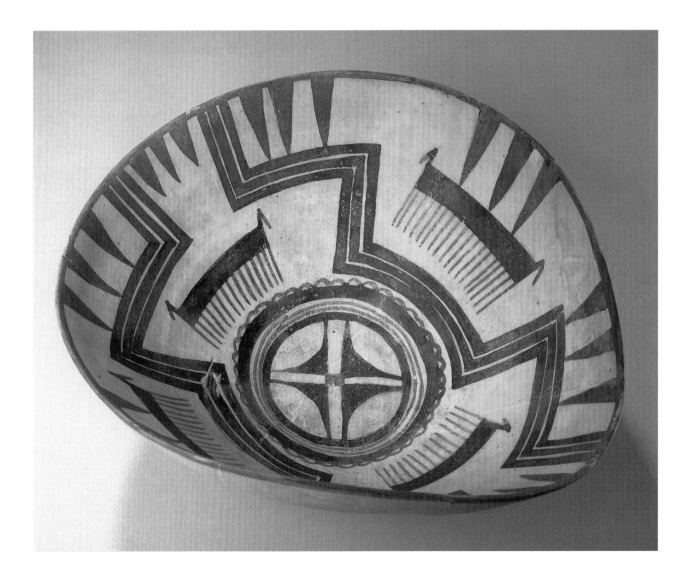

## 28

*Large beaker decorated with waders
and flying birds*

Susa I, Proto-urban period, 4200–3800 BC
Painted terracotta
7⅞ × 7 × 3⅜ inches (20.1 × 17.8 × 8.6 cm)
Excavations R. de Mecquenem, 1910–1911
Department of Near Eastern Antiquities,
Sb 3216

## 29
*Carinated jar decorated with flying birds*

Susa I, Proto-urban period, 4200–3800 BC
Painted terracotta
3½ × 4¾ inches (8.9 × 12.1 cm)
Department of Near Eastern Antiquities,
Sb 14386

## 30
*Anthropomorphic figurine with cylindrical body*

Susa I, Proto-urban period, 4200–3800 BC
Terracotta
1⅝ × 1 inch (4.1 × 2.5 cm)
Excavations J. de Morgan, 1911
Department of Near Eastern Antiquities,
Sb 6994

## 31
*Circular seal showing a genie
mastering animals*

Susa I, Proto-urban period, 4200–3800 BC
Beige limestone
⅝ × 1⅝ inches (1.5 × 4.1 cm)
Excavations R. de Mecquenem, 1924
Department of Near Eastern Antiquities,
Sb 5781

## 32
### Seal in the shape of a vulture

Susa II or Late Uruk period, Proto-urban
period, 3300–3100 BC
Marble
1 × 1⅝ × ⅜ inch (2.5 × 4.1 × 1 cm)
Excavations R. de Mecquenem, 1928
Department of Near Eastern Antiquities,
Sb 5782

## 33
### Bulla with cylinder seal impressions and numerical figures, containing tokens

Susa II or Late Uruk period, Proto-urban
period, 3300–3100 BC
Terracotta
2⅜ inches (6.1 cm) in diameter
Excavations R. de Mecquenem
Department of Near Eastern Antiquities,
Sb 1940

## 34
### Kneeling female worshipper

Susa II or Late Uruk period, Proto-urban
period, 3300–3100 BC
Alabaster
2½ × 1½ × 2 inches (6.4 × 3.8 × 5.1 cm)
Excavations J. de Morgan, 1909
Department of Near Eastern Antiquities,
Sb 3032–Sb 70

# 35
## *Royal male worshipper carrying a sacrificial goat*

Susa, Susa level IV A, Early Dynastic period, ca. 2450 BC
Alabaster
17¼ × 7 × 4 inches (43.8 × 17.8 × 10.2 cm)
Excavations J. de Morgan
Department of Near Eastern Antiquities, Sb 84

Statues of praying figures are the main source of evidence of Sumerian sculpture and piety during the third millennium BC. Men and women would have their portraits made in limestone or alabaster and place them in the temple of the divinity they wished to honor so their prayers would last forever.

The statue of a praying figure presented here indicates that Susa had come under the influence of the land of Sumer during the Early Dynastic period, since worshippers in Mesopotamia practiced the same custom. Whether seated or standing, most of the praying figures have their hands joined and some hold goblets, indicating their participation at a liturgical feast. But none of them carry an offering. This Susian figure is thus unusual in the exceptional kid he holds in his arms. Besides this detail, the statue conforms perfectly to the Sumerian tradition. He wears a garment with fleecy overlaid fringes, known in the land of Sumer as a *kaunakes,* even if the seven rows exceed the customary three or four. This *kaunakes* shows an animal's tail at the back attached to the belt. The continuous eyebrows, at one time inlaid with additional materials (since lost), are also Sumerian conventions.

A princely worshipping figure made of gold found in the temple of Inshushinak in Susa also holds a goat in his arms, which may well be a local custom. An amusing detail on the alabaster statue stands out: the fleece of the little animal is rendered with the same stylized triangular tufts as that of the *kaunakes.*

The man represented here was a person of high stature: the flap of fabric draped over his left shoulder was characteristic of a princely or royal statue after 2450 BC. The coiffure is particularly elaborate and complex, recalling that of Kings Meskalamdug of Ur, Eannatum of Telloh, and Lamgi-Mari of Mari. His hair, indicated by parallel lines on top of the head, is parted in the middle and secured by a large horizontal braid, which falls softly along the sides of his face before being collected into a chignon at the back.

The size of the statue is in itself remarkable. In its present state, it is the largest Susian statue discovered, and we must restore the extremities of the legs and feet that should appear below the skirt. It was quite common to carve the body from a single block of stone and then attach the lower limbs separately.

The artisan has demonstrated an undeniable sense of anatomy: the muscles are rounded and not schematized into geometric forms. The curve of the shoulders is well-defined, as are the biceps. This new approach to the body will become characteristic of the Akkadian Empire but is just emerging in the late Dynastic Period III. It also characterizes the sculpture of Mariote praying figures, magnificently incarnated at the Louvre by the *Ebih-Il, the superintendent of Mari.*

Alabaster is a noble material that permits a great many details, but at the same time it is very fragile and sensitive to humidity. The extreme wear seen all over the statue is undoubtedly due to contact with water, which has corroded its surface.

AGNÈS BENOIT

## 36
*Female figurine with pellet decoration,
holding hands between her breasts*

Susa IV B, Akkadian period, 2340–2200 BC
Terracotta
3½ × 1½ inches (8.9 × 3.8 cm)
Excavations J. de Morgan, 1907
Department of Near Eastern Antiquities, Sb 7727

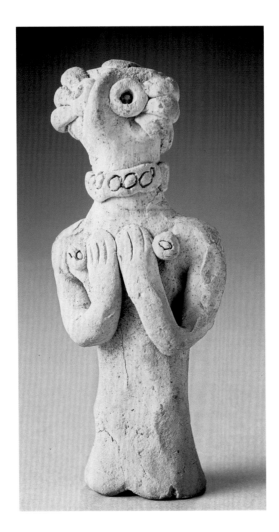

## 37
*Molded figurine: naked woman with excessively*
*large hips, supporting her breasts*

Susa, Middle Elamite period, 14th century BC
Terracotta
6⅜ × 3¾ × 2 inches (16.3 × 9.5 × 5.1 cm)
Excavations R. de Mecquenem, 1928–1929
Department of Near Eastern Antiquities, Sb 7797

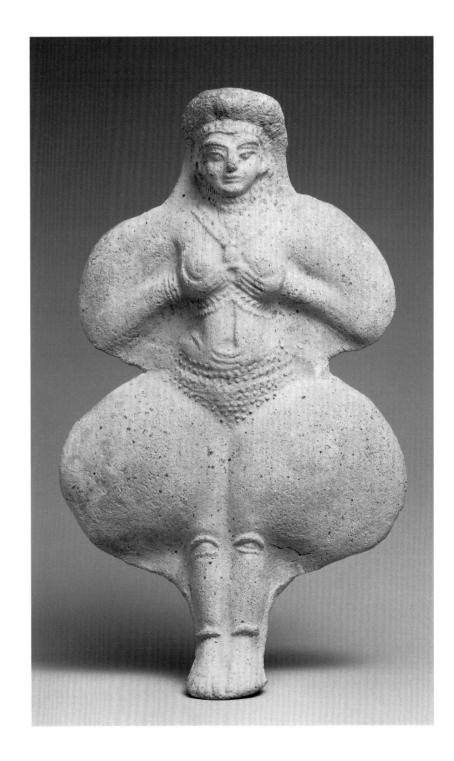

## 38
*Bull-Man decoration from the dynastic temple of Susa*

Middle Elamite period, Shutrukid Dynasty, reigns of Kutir-Nahhunte
and Shilhak-Inshushinak, 12th century BC
Apadana mound and Royal City, Susa
Molded and baked clay bricks
54 × 14½ inches (137.2 × 36.8 cm) (for each element)
Inscription in Elamite script
Excavations R. de Mecquenem, 1913–1921
Department of Near Eastern Antiquities, Sb 21960

On this bas-relief made up of fourteen tiers of superposed bricks, a bull-man extends his arms to the left to touch the palm tree on the adjacent panel. The relief decorated the outer wall of a temple at Susa dedicated to Inshushinak, the protective god of Susa, the Elamite capital of the Susian Plain. The sanctuary, situated on the Apadana mound near the exterior wall of the city, was not only dedicated to divine worship but also to royal worship of the dynasty.

The architectural decoration on the panel façades of baked molded bricks alternates between the figure of a bull-man, associated with the palm tree, and that of Lama, a goddess whose function within the Mesopotamian pantheon was to intercede with the major gods on behalf of the faithful. The score of bull-man heads unearthed suggests that these relief decorations were repeated around the entire perimeter of the wall. The inscriptions engraved across the figure's torso state that King "Kutir-Nahhunte ordered these representations to be made on baked bricks" to decorate the temple, that his untimely death had interrupted his project, and that his brother and successor, Shilhak-Inshushinak, saw to its completion. Bull-men and Lama goddesses are protective divinities. The bull-men are seen here in their customary role as guardians of temple gates who repel evil forces. But their association with fruit-laden palm trees, symbols of plant life given life by spouting waters, indicates their nurturing function as ensurers of fertility.

As in the case of the Frieze of Archers (cat. 39), the molded bricks of the Susian sanctuary were re-used in the construction of later works and so were not discovered intact in their original arrangement. The placement of the bull-man's hands on the tree confirms the original juxtaposition of these two panels; however, the structure of the grouping in which these figures were integrated remains unknown. As with the archer frieze of the palace of Darius, this panel was recently reassembled.

AGNÈS BENOIT

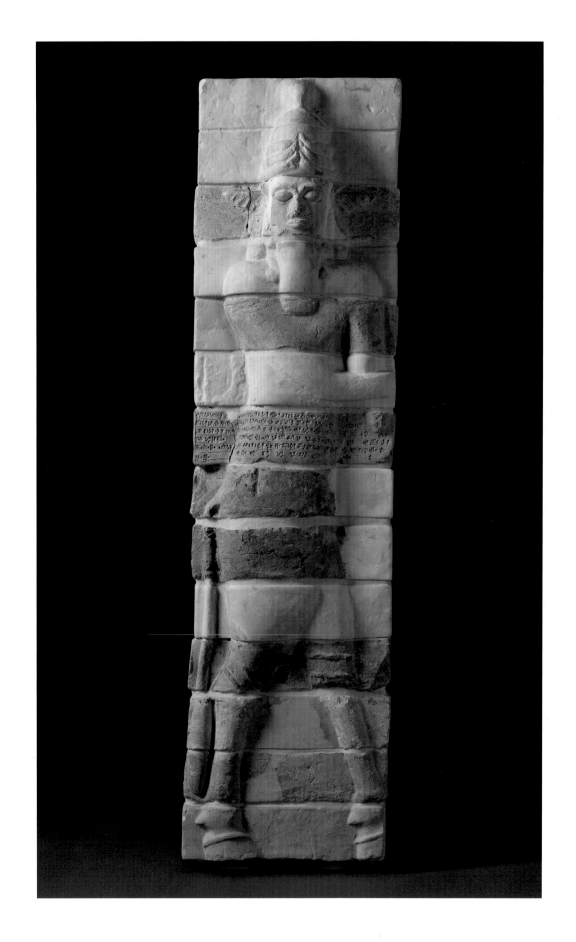

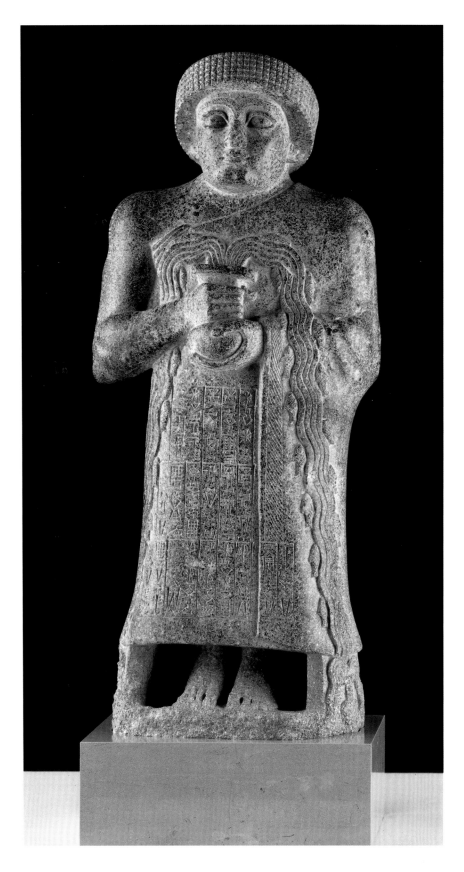

Fig. 8. Libation vase of Gudea, found in sanctuary of
Ningizzida, Telloh, reign of Gudea, ca. 2120 BC, green
stone, 9 inches (22.8 cm) high, Musée du Louvre,
Department of Near Eastern Antiquities, AO 190.

Fig. 7. Statue of Gudea offered to the goddess Geshtinanna, Telloh,
reign of Gudea, ca. 2120 BC, dolerite, 24⅜ inches (62 cm) high, Musée
du Louvre, Department of Near Eastern Antiquities, AO 22126.

was dedicated to Ningirsu, tutelary god of the principality of Lagash. The story of this undertaking, inscribed on two large clay cylinders, is a long poem—one of the longest Sumerian texts known—that relates how Gudea was charged in a dream with the mission of constructing E-ninnu by the messenger of the goddess Nanshe.

The poet recounts the preparations, telling how Gudea brought artists and materials from distant lands, "like great serpents, the cedars descended the Cedar Mountain [the Amanus Mountains] floating on the waters of the river. . . . From the Mountain of Copper of Kimash . . . we brought so much gold as if it were dust. . . . For Gudea we mined silver from the mountains and brought vast quantities of red stones from Melluhha. . . ." Once the construction was complete, "the glory of E-ninnu covered the universe like a coat." Sadly, there are few remains of the buildings Gudea commissioned in Girsu, since the first excavators irremediably destroyed the walls of unbaked brick through a lack of experience and technique; however, stone statues and stelae have been passed down to us.

There are about twenty statues attributed to Gudea, seventeen of which bear inscriptions of his name; most of them were discovered by de Sarzec during the first excavation expeditions and are today housed at the Louvre. They were placed in various sanctuaries and bear inscriptions stating the name of the god or goddess to whom they were dedicated. The prince is represented seated or standing, draped in a long linen cloak, hands joined in a gesture of eternal prayer. On a statue (fig. 7) offered to the goddess Geshtinanna, wife of his personal god Ningizzida, Gudea holds a vase with flowing water, a symbol of fertility that was a common attribute of the divinities. He thus appears as the master of fecund waters, administrator and guarantor of prosperity for the city of Lagash.

The stelae that decorated the major temples of the city have been ruthlessly shattered, but the surviving fragments that have come down to us show divinities, worshippers, and groups of musicians whose instruments gave rhythm to cult ceremonies. If these reliefs help us imagine the atmosphere of the temples, many texts illuminate the rituals that took place there, giving us the inventories of furnished goods: bronze receptacles, linen clothing, precious furniture. Unfortunately, only a tiny portion of these luxurious items have been found. One of the most moving and most spectacular is the libation vase of Gudea, found in the sanctuary of Ningizzida (fig. 8). This tall cone made from a green stone is decorated in relief with interlaced horned snakes and eel-shaped dragons, aco- lytes of the chthonian god of vegetation.

A small group of statuettes representing reclining bulls was sculpted with exquisite subtlety from the same rock (see cat. 47). The human heads and multi-tiered horned tiaras adorning them announce that these are divine creatures. These are the protective and benevolent demigods attending the forces of fertility and the fecundity of the earth. These human-headed bulls recur during the Assyrian period, posted as sentries before the palace gates. On the back of the animal a little cavity has been made to hold a vase, into which wor- shippers would place various offerings: a few grains of incense, perfume, and gold leaves that were supposed to bring them into the good graces of the divinity.

Under the reign of Ur-Ningirsu, the son of Gudea, and his successors, the state of Lagash lost its importance and ultimately was incorporated into the empire that the prince of the city of Ur, Ur-Nammu (2112–2095 BC) had consoli- dated under his authority. Archaeologically, this period of the Empire of Ur III is not well documented at Telloh. The sanctuary of Ningirsu was restored and the town became an important city of the empire according to numerous adminis- trative tablets and countless cylinder seals found there. But beginning in the early second millennium BC, the city fell into decline and was most likely deserted in the seventeenth century BC, following the reign of Samsu Iluna.

After centuries of disuse, Telloh was reoccupied in the second century BC by the head of a local principality. Adad- nadin-ahhe had a palace built on the ruins of E-ninnu, where bricks have been discovered inscribed with his name in Aramaic and Greek scripts.

In what must have been one of the courtyards of this palace, de Sarzec discovered many statues of Gudea that had probably been intentionally collected by Adad-nadin-ahhe as a way of showing his respect for the past. The palace was occupied until the second century AD.

## 40

*Foundation peg inscribed with the name of Ur-Nanshe,
King of Lagash*

Telloh, Mesopotamia, Early Dynastic period III,
reign of Ur-Nanshe, ca. 2500 BC
Copper alloy (bronze)
Figurine 4¼ × 1⅜ × 1 inch (10.8 × 3.6 × 2.5 cm);
Ring 4½ × 2⅞ × 2¾ inches (11.4 × 7.4 × 7 cm)
Excavations de Sarzec, 1881
Department of Near Eastern Antiquities, AO 314

In ancient Mesopotamia, the construction of the temple was
one of the king's most fundamental obligations; in return,
the divinity honored would ensure the people's prosperity. The
event was marked by large ceremonies in which ritual objects,
such as these pointed figurines, were placed directly into the
foundations.

These "foundation nails" were embedded in the walls or
buried during the building of the shrine. Their purpose was to
symbolically anchor the building to the ground, and they also
had a protective role in helping subdue the evil spirits who ruled
the underworld, rendering them harmless. With the develop-
ment and spread of writing, they also proclaimed the name of
the builder of the shrine to posterity and the divine world.
This nail ends in a sharp-edged point and is surmounted by a
bust of a male nude with long hair, his hands clasped across his
chest in prayer. The figurine, which most likely represents a
benevolent genie, was passed vertically through the ring, which
terminates in a dovetail bearing an inscription.

This example is inscribed in the name of King Ur-Nanshe,
the founder of the first dynasty of the state of Lagash, ca. 2500 BC,
whose holy city was Girsu (modern-day Telloh). Since many
such nails have been collected, it has been possible to reconstruct
the text in its entirety by combining the various inscriptions:
*"Ur-Nanshe, king of Lagash, son of Gunidu, built the house of Girsu"*
(Sollberger translation). A rounded stone tablet (see cat. 41)
was placed both on top of the figure and below the base of the
pin, shaped to look like the bricks used for construction in this
period, bearing an inscription enumerating the various structures
built by Ur-Nanshe. This ruler built a large religious complex,
including a temple to the god Ningirsu, the city's guardian deity,
over the ruins of an earlier shrine, designated "Lower construc-
tion." Some thirty-five uninscribed foundation nails were found
at this lower level, which testifies to the antiquity of using
anthropomorphic figurines in Telloh's foundation rites.

The tradition of foundation nails, of which there is scant
evidence in the Akkadian period, survived into the Neo-
Sumerian period and died out around the early second millen-
nium. But their shapes evolved and new types appeared. Certain
"nails" bear the shape of a male character, representing the king.
His head shaved and naked up to the waist, he carries a basket
full of clay on his head to be used in brick-making. Other nails
are surmounted with a recumbent bull or with a kneeling divin-
ity wearing a tiara with multiple rows of horns (see cat. 46). This
guardian god holds a stake in front of him that he is about to
drive into the ground. These last two types appear to have been
used exclusively in Telloh.

**FRANÇOISE DEMANGE**

## 41

*Foundation brick with the name of Ur-Nanshe,*
*King of Lagash*

Telloh, Mesopotamia, Early Dynastic period III,
reign of Ur-Nanshe, ca. 2500 BC
Gypseous alabaster
6⅞ × 4 × 2¾ inches (17.5 × 10.2 × 7 cm)
Excavations de Sarzec, 1881
Department of Near Eastern Antiquities, AO 253

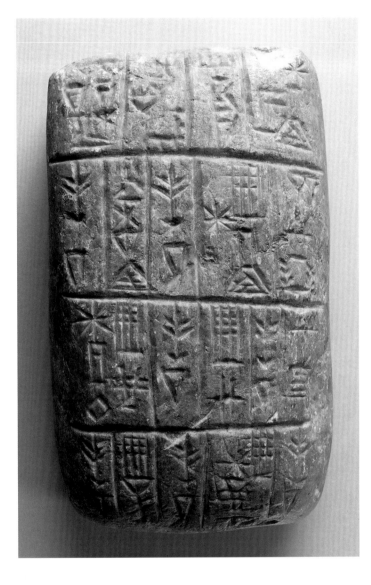

## 42

*Basket label with cylinder seal impression naming*
*"En-ig-gal, scribe of the House of the princess"*

Telloh, Mesopotamia, Early Dynastic period III, ca. 2400 BC
Clay
2½ × 2½ inches (6.4 × 6.4 cm)
Department of Near Eastern Antiquities, AO 13223

## 43
*Tablet listing cattle brought to the temple
of the goddess Ba'u*

Telloh, Mesopotamia, Early Dynastic period III, reign of Urukagina,
ca. 2350 BC
Clay
3 inches (7.6 cm) high
Department of Near Eastern Antiquities, AO 13307

## 44
*Statue of Prince Gudea in prayer*

Telloh, Mesopotamia, Neo-Sumerian period, reign of Gudea,
ca. 2120 BC
Dolerite
42⅛ × 14⅜ × 9⅞ inches (106.9 × 36.6 × 25.1 cm)
Department of Near Eastern Antiquities, AO 20164

This statue can be identified as an effigy of Gudea, prince of the state of Lagash, even though it bears no inscription. Its full, rounded face and square chin are similar to those of statues dedicated by Gudea for the various sanctuaries of Girsu. The prince is shown standing, his hands clasped at the waist, in an attitude of respect and piety. He wears a round, fur-trimmed cap, a headdress that was a sign of royalty beginning in the early second millennium BC; in Babylon, Hammurabi wore an identical cap.

Gudea is dressed in a long, draped robe, probably made of linen, which leaves the shoulder and right arm bare. The accentuated modeling of musculature confers an impressive power to his profile, contrasting with the geometric rendering of the lower half of his body, which melds into a cylindrical mass and gently flares from the toga, its folds subtly suggested. The statue is carved in dolerite, a very hard volcanic rock, probably imported from Magan, a country considered to have been in either Iran or Oman. The passion for these very hard stones brought from faraway countries reached its height under Gudea's reign. The sculptors in the royal workshops of Girsu had inherited stone-sculpting techniques perfected during the Akkadian period, and the series of statues of Gudea demonstrates the exceptionally high quality of their craftsmanship. These pieces have often been criticized for their academic rigidity, but in the artistic universe of official workshops, there was no room for originality of expression. A monument ordered by a ruler had to meet certain iconographic criteria. Its quality depended on the technical mastery with which the sculptor had been able to reproduce a certain number of significant elements, such as the attitude of the character, details of the clothing, or an athletic musculature. The statues of Gudea leave to posterity the likeness of a pious and serene prince—an image sought by the prince himself.

**FRANÇOISE DEMANGE**

## 45
*Fragmentary tablet: myth of Lugal-e
(the revolt of the stones)*

Telloh, Mesopotamia, Neo–Babylonian copy, ca. 626–539 BC
Clay
2½ × 1½ × 1 inch (6.4 × 3.8 × 2.5 cm)
Department of Near Eastern Antiquities, AO 7748

## 46

*Foundation peg representing a kneeling god, inscribed with the name of Gudea, prince of Lagash*

Telloh, Mesopotamia, Neo-Sumerian period, reign of Gudea, ca. 2120 BC
Copper alloy (bronze)
8½ × 1⅝ × 3 inches (21.6 × 4.1 × 7.6 cm)
Excavations de Sarzec, 1881
Department of Near Eastern Antiquities, AO 76

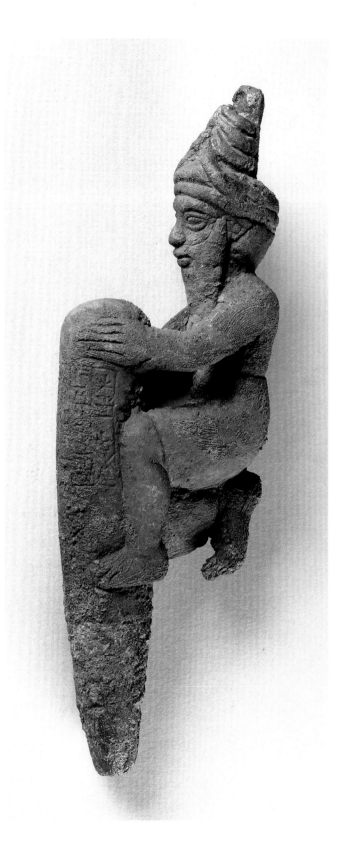

## 47
### Human-headed bull

Telloh, Mesopotamia, Neo-Sumerian period,
end of 3rd millennium BC
Black steatite
5¾ × 3⅛ inches (14.6 × 7.9 cm)
Department of Near Eastern Antiquities, AO 2752

48
*Male head*

Telloh, Mesopotamia, Neo-Sumerian period,
end of 3rd millennium BC
Black-green diorite
2½ × 1½ × 2 inches (6.4 × 3.8 × 5.1 cm)
Excavations G. Cros, 1904
Department of Near Eastern Antiquities, AO 4351

49
*Sumerian religious text: The Passion of the God Lilu*

Telloh, Mesopotamia, beginning of the 2nd millennium BC
Clay
4¾ × 2⅜ × 1¼ inches (12.1 × 6.1 × 3.2 cm)
Department of Near Eastern Antiquities, AO 3023

## 50

*Molded plaque representing a female nude*

Late third millennium/early second millennium

Telloh

Terracotta

7 × 3 × 1 inch (17.8 × 7.6 × 2.5 cm)

Department of Near Eastern Antiquities, AO 12205

## 51

*Molded plaque representing a sitting goddess*

Late third millennium/early second millennium

Telloh

Terracotta

4⅛ × 2 × ¾ inch (10.4 × 5.1 × 1.9 cm)

Department of Near Eastern Antiquities, AO 4593

## 52

*Molded plaque representing a man carrying a kid*

Late third millennium/early second millennium

Telloh

Terracotta

4¾ × 2⅛ × ⅞ inch (12.2 × 5.4 × 2.1 cm)

Department of Near Eastern Antiquities, AO 16721

These three stamped clay reliefs belong to a category of objects that were particularly popular in the Mesopotamian world and have been found in great numbers in archaeological sites. They began appearing around the end of the third millennium BC, but it was during the first centuries of the second millennium BC that they reached their greatest popularity. These small reliefs are sometimes compared to today's devotional images. Visitors to the temple could buy them as offerings to leave in the shrine or to take home for their household altars. They were also placed in sepulchres to accompany the dead in the afterlife. They were probably produced very cheaply in temple workshops, thanks to the invention of the single-valve or open mold. These charmingly fresh (sometimes naive) plaques depicted gods, worshippers making offerings, nude female forms, and embracing couples (probably used in fertility rites), as well as animals, acrobats, or temple musicians.

Female nudes were frequently represented and were undoubtedly associated with fertility rites. Here, emphasis is on the sex characteristics: the voluptuous bosom, wide hips, and exaggerated pubic triangle all accentuate the character's femininity. Against her chest she holds a tambourine-like circular object. A veil under which can be seen two heavy crescent earrings covers her hair; a variety of necklaces adorn her neck, and an ovoid pendant lies between her breasts—perhaps a representation of the "conception stone" meant to protect women in labor, as mentioned in ancient texts.

On the second plaque, the character seems to be seated on a kind of throne. This woman wears the loose robe of divinities and an imposing headdress decorated with grooves. She most likely represents a richly clothed and adorned votive statue. This headdress is not the traditional horned tiara characteristic of the gods and goddesses, but thanks to contemporary texts we know that in ancient Mesopotamia sacred statues had their own wardrobes of clothes, headdresses, and jewelry. The priest appointed to serve the divinity could modify the figure's appearance according to specific religious celebrations and rites. The goddess clasps a barely identifiable, flat, flared object, possibly a palm tree symbolizing fertility and fecundity. The two little rosettes that frame her head are most likely astral symbols, confirming the divine nature of this woman, who could be a goddess connected to Ishtar, the goddess of love.

The third plaque depicts a man carrying a sacrificial kid. Dressed in a draped robe that leaves one shoulder bare, he wears on his head the domed, high-rimmed crown cap worn by Gudea and the kings of the third dynasty of Ur, and also worn by Hammurabi. His long, curly beard falls over his chest, leaving only one part of his heavy necklace visible, suggested by a bulge. The jewelry and clothing indicate a person of royal stature. This same figure of a ruler appears in many cylinder seals connected with divinities—mainly Shamash and Adad—from the early second millennium. These were the gods invoked in divinatory rituals during which omens were read from the entrails of a sacrificed animal. The representation of a king carrying a kid goat could refer to this highly popular ritual of the early second millennium.

FRANÇOISE DEMANGE

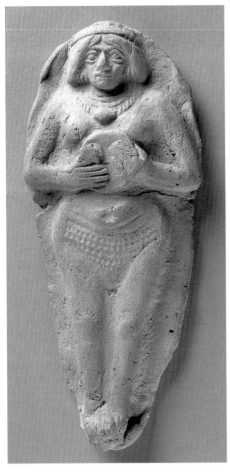

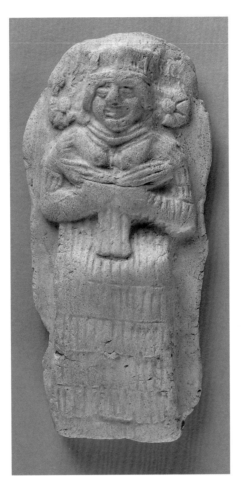

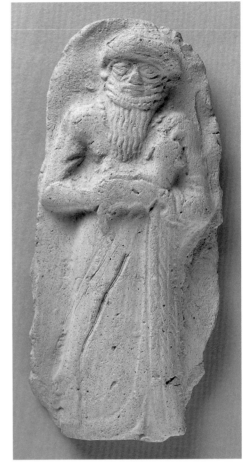

50                                  51                                  52

# Ras Shamra, Capital of the Kingdom of Ugarit

*Sophie Cluzan*

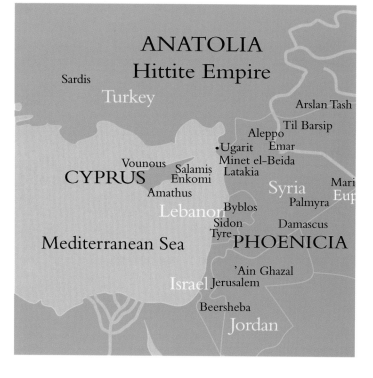

Located on the Syrian coast of the Mediterranean, Ugarit was one of the flourishing cities of the Ancient Near East. Archaeological work, which began at the site in 1929, has shown the importance of the kingdom of Ugarit—at the center of a geographical location known in the Bible as Canaan—dating back to 2500–2000 BC. The site was discovered by chance when a peasant noticed a tomb in the seaside hamlet of Minet el-Beida. France, which was the mandatory power in Syria from the end of the First World War, dispatched Claude Schaeffer to the site (fig. 1). The importance of the discoveries at the Minet el-Beida site sparked interest among searchers in a nearby mound, Ras Shamra. Work was swiftly undertaken there and the results immediately justified the interest in the site, whose former name, Ugarit, quickly reappeared thanks to epigraphic finds. Amid the monumental architectural remains and the countless exceptional objects unearthed, documents written in a hitherto-unknown language emerged, providing a new perspective on our view of Biblical texts.

Excavations have been ongoing ever since Ugarit was discovered. In accordance with the law in force until 1939, the archaeological artifacts discovered at the site were shared between Syria and France, an agreement that permitted the Louvre's Department of Near Eastern Antiquities to collect a rich trove of objects. Following World War II, France continued to play an important role in archaeological research in Syria, notably at this site, where it was granted authority for scientific direction. Since 1998, this direction has been mutually assured by Syria and France, and in recent years the traditional cooperation between the Louvre and the Syrian Directorate-General of Antiquities and Museums has been particularly focused on research activities and restoration of the Ugarit collections at the museums of Damascus, Aleppo, and Latakia and in the continued development of the site.

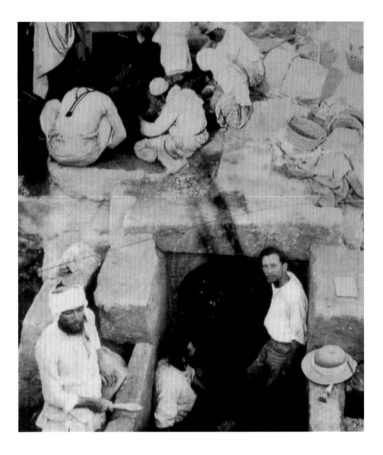

## THE SITE

The artificial mound (tell) formed by the accumulation of detritus from human occupations is located about one kilometer from the coast. Human occupation there goes back to the eighth millennium, from which time it was occupied almost continuously up to the early twelfth century BC. Over time, the original village became a city, which expanded rapidly in the third millennium. The center of a rich kingdom in the fourteenth and thirteenth centuries BC, the city was destroyed in the early twelfth century BC, as were other Near Eastern kingdoms during the same period. Today, research in the area of the former royal palace is seeking to establish an exact date of the city's disappearance and a possible link between its fall and the appearance of the "People of the Sea," peoples from the north arriving by sea in successive waves and spreading throughout the eastern Mediterranean.

The importance of the remnants from the last period of occupation at the site from the Late Bronze Age in the fourteenth and thirteenth centuries BC makes it difficult to search the underlying strata containing the previous occupations. Therefore, the history of Ugarit during its more ancient periods largely escapes us, even if some texts from other kingdoms such as Mari or Ebla attest to the city's existence around 2500 BC. On the other hand, the final phase of its occupation during the Late Bronze Age is relatively well known. During this period, Ugarit is mentioned by most of the states in the region, from Anatolia to Egypt, reinforcing the general impression of a thriving and powerful kingdom. Thus, the collected remnants from the city, taken together with the documentation from exterior sources, show that Ugarit was an important city from 2500 BC—and thus must have enjoyed an even earlier development—and that it flourished up to 1200 BC.

In the Late Bronze Age, the kingdom ruled over a vast fertile territory, open to the sea at the port of Mahadu, today's Minet el-Beida. The city enjoyed a strategic geographic position, at the nexus of several communication routes that connected various territories and seats of major powers such as Egypt, Greece, Cyprus, and Anatolia. Finally, toward the east, Ugarit linked the coastal plain to the interior of the Syrian territories and beyond to the lands of the Euphrates, from Mesopotamia to the Gulf. This location conferred on the kingdom an indisputable power and a considerable amount of wealth. The ruling powers maintained diplomatic relations with neighboring countries, while the citizens from all of these regions met in the city's streets. Coupled with the power of thousand-year-old local cultural traditions, this cosmopolitanism expressed itself in the arts and culture. The kingdom was an important artistic center where products

Fig. 3. Stele depicting the storm god Baal, Ugarit, 15th–13th century BC, sandstone, 56 × 22⅝ inches (142 × 57.5 cm), Musée du Louvre, Department of Near Eastern Antiquities, AO 15775.

complete documentation to date on the gods cited in the Old Testament as the Canaanite gods, idols vilified by the theologians but attractive to the general populace. In those texts dedicated to the exodus of the Jews and their journey to the Promised Land, the Bible records the direct relation between the Jewish people and the beliefs of the indigenous populations. Up to the early twentieth century, the Bible was the only text from which to learn about such beliefs, but with the rediscovery of Ugarit, the names of the local gods cited by the Bible have resurfaced in their proper context and furnish, for the first time, a direct documentation of what the Old Testament (redacted over the course of the first millennium BC) called Canaan. If this point of religious history is worth mentioning in illustrating Ugarit's importance, it is because of the relationship between Ougaritic and Biblical texts that excited and continues to excite considerable attraction for the site. Besides a commonality of form and sensitivity to phraseology and vocabulary, the Ougaritic texts have brought to light the existence of a common cultural and religious ground with the Old Testament. These discoveries have shown that through its traditions the land of Canaan informed the redaction of the Old Testament.

## El

The myths of Ugarit inform us about its pantheon, the "assembly of the gods" over which presided the great god El. The name of this god, "el" in Ougaritic is identical to the word "god"—"elou(m)" in Akkadian, "elohim" in Hebrew, and "allah" in Arabic—which shares a root common to all Semitic languages, according to a tradition that designates the concept of divinity by the name of the major god. Head of the pantheon, El incarnates old age and its qualities: knowledge, wisdom, justice, and kindness. He is the "Merciful and Generous," according to a title close to the one the Koran attributes to Allah: "the Merciful and the Compassionate." He is the "father of the gods" and the "father of humankind," the "creator of all created things," and the "father of time," an expression close to that used in Biblical texts to name the God of Israel: "the Ancient of Days." The Hittite translation of an Ougaritic text that refers to El as "Creator of the Earth" brings him closer to the personality of the God of Israel: "El (Elyōn), Creator of the heavens and the earth" (Genesis 14:19). At the source of Ugarit's dynastic power, El nonetheless assumes a universal character, since certain foreign kings called themselves his "son" or "servant," which is rare in the religious systems of the ancient Near East, where a national (indeed, nationalist) conception of the pantheon prevailed.

## Baal

Alongside El's passive wisdom, the dynamism of the young Baal assured the continuation of order on earth. Thanks to his beneficence and life-saving power, this Storm God, named Haddu—more often designated by his title, Baal or "Master"—was at the center of the city's religious life and became its defender (cat. 67). Considering the totality of the qualities he incarnated and the vital needs they satisfied for the kingdom, Baal was the central figure of the Ougaritic myths, and it is to him that the largest collection of literature is dedicated.

Although Baal was the son of Dagan, a god foreign to the city, El considered Baal as a son and granted him great freedom of action. As the Storm God, Baal could make his "voice" heard. Thus in the myth of Ugarit concerning the construction of his palace, Baal manifests himself by visiting his kingdom: "Baal parted the clouds. Baal made his holy voice heard. Baal repeated what left his lips, his voice [missing] the earth [missing] the mountains shook afar [missing] before (?) the highest places of the earth sprang up," a passage that recalls the voice of Yahweh as described in several of the Psalms: "The voice of the LORD is upon the waters: the God of glory thundereth. . . . The voice of the LORD breaketh the cedars; yea, the LORD breaketh the cedars of Lebanon. He maketh them also to skip like a calf; Lebanon and Sirion like two young buffalos. The voice of the LORD divideth the flames of fire . . ." (Psalm 29).

Baal's dwelling was on Mount Sapon, known today as Jebel al-Aqra, on the northern horizon of the city, whose high peaks reached to the clouds. Thus Baal was a god of the mountain, a quality that would also be attributed to the God of the Bible, referred to as el Shaddaï, "mountain man," applied more than three hundred times to Yahweh. In the ninth century BC, the advisors of Ben-Adad, the King of Aram (Damascus), referring to their Israeli adversaries, said that "Their god is the God of the Mountains." As the mountain is the place where the clouds collect, the bond between its occupant and its climatic and astronomical manifestations has fostered coastal religious tradition from time immemorial, constituting one of the cultural tendencies that the redactors of the Biblical texts lived and breathed as they applied the image of this association between god and mountain.

The most commonly used epithets for Baal were "Mightiest," "Prince," and "zbl" in Ougaritic (most likely pronounced "zaboul"), from which derives a name of the Prince of Devils: Beelzebub (ba'al zebub). Finally, he is often called "Calf" or "Bull," in reference to the fertility he granted

Fig. 4. Figurine of Baal, Ugarit, 14th–12th century BC, bronze and gold, 7¼6 inches (18 cm) high, Musée du Louvre, Department of Near Eastern Antiquities, AO 11598.

to the earth, according to the natural cycle of the seasons. This assimilation of the god of providence into a bull, leading to the worship of the animal in place of the god, is widely illustrated in the texts of the Old Testament, which condemned it—most sharply in the story of the Golden Calf.

## Myths of Ugarit

The myths take place in the world of the gods, a space where their personalities complement each other in a concerted effort to safeguard cosmic order and maintain its harmony. All the major elements of life on earth are in the hands of a few gods, most notably Baal's. Among the many texts that make up the *Epic of Baal,* two stories concern the recurring clashes of this god with Yam (the Sea) and with Mot (Death) (see cat. 66). These two struggles recount the beneficence of the god who, on the one hand, keeps the watery element confined within its assigned zone and, on the other, sustains nature through an annual cycle of vegetation, wherein death and rebirth follow one another continually.

## Baal and the Sea

In his battle against Yam, Baal succeeded in making the Prince of the Sea a captive within the limits of his realm, according to an image close to that used in numerous religious creation stories. A particularly striking episode from these creation stories recounts the battle of the Demiurge against the primordial waters, symbolizing original chaos. The tradition of an initial battle between order and chaos seems to have its roots far back in the history of Near Eastern religious thought. Even going back to the third millennium BC, a text from the Akkadian period (2334–2193 BC) speaks of a battle of Tishpak, a major Semitic god, against the Sea's waves. In the eighteenth century BC, a text from Mari on the Euphrates attests to the battle of Addu, the god of Aleppo (and the local storm god) against Temtum (the Sea). And finally, from the late second millennium BC, the Babylonian *Epic of Creation* takes up the theme of this primordial battle by a Demiurge against the chaos of the original waters. This is a necessary prelude to the creation of order in the universe, which is surely expressed in the Ougaritic story from the middle of the second millennium BC, in which Baal would become the Demiurge. In the Old Testament, these evocations of an extremely ancient entity that opposes the god, the savior of order from original chaos and its possible return, find expression in the divine action depicted in Genesis, from the creation to the flood, and glorified in several of the Psalms.

## Baal and Death

In the story of the battle between Baal and Mot, the god of life-giving rain was commanded to descend into the mouth of Death. With him went the rain, placing all of humanity in danger. The goddess Anat, Baal's sister, whose name means "springs of water," retrieved his body, then with the help of the Sun goddess Shapash carried him up to the summit of the mountain, at the junction of heaven and earth. Anat then set off immediately to find Mot and tore him limb from limb. Baal returns to life and is enthroned once more upon his mountain in a prelude to the rebirth of vegetation.

Rain, the source of life, must penetrate the earth at the heart of the mountain, the residence of death, then return to the sky to become cloud again. The earth is nourished by this water from Baal, but in order for life to continue, the clouds must rise up over Mount Sapon anew. As her name indicates, Anat is the spring to which all the earth's moisture (the seed of Baal) returns, while Shapash evokes the role of the sun in evaporating water—a metaphor of Baal's departure from the mountain to remake the clouds.

The vital bond between water and the area's farmers explains why the Storm God held such a central importance in the people's hearts. The strength of Baal's anchoring in the local religious life can be read in the Bible, where he is presented as Yahweh's most fearsome adversary, since it is essentially toward him that the people of Israel settling in Canaan turned, since their destiny depended upon the same meteorological factors as those of the indigenous people. The legislators and prophets thus condemned the "Baalim"—the name of Baal turned into a common, plural noun and used as a generic term for the "stranger gods," or "idols." The importance of their condemnation throughout the Biblical texts demonstrates the fervor with which this god of providence and fertility was regarded during the centuries that Israel's founding religious texts were being redacted. In the Bible, the history of this people can also be read as a succession of waves of enthusiasm for idolatrous worship, followed by condemnation, punishment, and then a return to the fold.

While Baal may have been strenuously rejected by the new faith, the religious images and literature associated with his personality have served paradoxically as models for thinking and talking about the god of Israel. Beyond seeing in this a transfer from one form of religious thought to another, it is conceivable that the use of images linked with a popular local god may have given rise to a desire to renew the adherence of a newly settled people, seduced by the agrarian worship of a population with whom they were trying to share the

agricultural way of life. This borrowing of a form of thought recurs in numerous places in the Old Testament, notably in the Psalms and in the Book of Job, but there is no evidence to support a possible semantic transfer.

## UGARIT AND THE BIBLE: A SHARED HERITAGE

To date, the texts from Ugarit provide the sole direct evidence of the religion and mythology of Canaan, showing that there is a legacy from this culture in the Old Testament, representing a part of the traditions on which the redactors of the Bible relied. This heritage can be read on several levels. First, on the linguistic level, philologists have recognized a great many resemblances between the vocabularies and forms of Ougaritic and Biblical Hebrew. On the level of form itself, Ougaritic and Biblical poetry rely upon similar rhythms and cadences, as well as employing a very similar phraseology.

Moreover, the themes in the myths of Ugarit find many echoes in the texts of the Bible. In particular, the divine battle against the waters, the source of formlessness and chaos, is an expression of the relation of the divine to the element of water that the divinities must control to ensure the order of the universe. Finally, the expressions and images used to depict Baal and Yahweh testify to an authentic cultural kinship. Like Baal, Yahweh is named "[He] that rideth upon the heavens" (Psalms 68:4), Baal dwells on Mount Sapon, in the north of Ugarit, and Yahweh dwells on a mountain at the northernmost reaches (Psalms 48:2–3). Like Baal, Yahweh makes his loud voice heard (Psalms 29:3–4; Jeremiah 25:30)— i.e., thunder—and, like Baal, Yahweh is a king enthroned in the heavens and in the court of the sons of the gods decides: "God standeth in the congregation of the mighty; he judgeth among the gods" (Psalms 82:1).

The contours of a true kinship thus can be traced between the Ougaritic texts and those of the Old Testament, showing that this area has supplied, along with other Near Eastern areas, a part of the culture that was used as a basis and formal foundation of the thought and religious expression of Israel. Ugarit and Canaan yielded their religious reflections and terms to the theologians of Israel, who knew how to draw on those elements favorable to their own religious expression. This transmission of a thousand-year-old bequest from the Near East through the texts of the founders of the great monotheistic religions, underscores one of the bonds that connect all of our cultures to the lands of the Near East.

## 53

*Tablet bearing an Akkadian text and mark of the dynastic seal of the kings of Ugarit*

Ugarit, late Bronze Age, reign of King Niqmepa, 14th–13th century BC
Clay
2⅛ × 2 × 1 inch (5.3 × 5.1 × 2.5 cm)
Excavations Schaeffer
Department of Near Eastern Antiquities, AO 27987

This tablet bears the mark of the dynastic seal of the kings of Ugarit. Dating from the end of the dynasty, the tablet illustrates the longevity of the use of a cylinder seal of an illustrious ancestor by his successors. The story of this ancestor is unknown, but judging from the style of his seal, he would have lived during the early second millennium. The scene depicts the meeting between a standing figure, undoubtedly the king, and a seated figure who greets him. This image is typical of a characteristic iconography from the Mesopotamian world in the early second millennium. It thereby demonstrates extremely strong ties between Ugarit and the Mesopotamian plain. The fact that this image was still the one chosen to represent the monarchy of the city in the fourteenth and thirteenth centuries BC clearly demonstrates that the kings still acknowledged their Mesopotamian identity, related to this ancestor.

One of the distinctive features of the dynastic seal of the kings of Ugarit was to have had a copy made, meaning that two seals were in use: the seal dating from the early second millennium and its copy (dating by the style) from around the fifteenth century BC. The legal tablet here has been sealed with a copy of the seal. Why the dynastic seal was copied at a given time period is still unknown, but it seems that the kings could use any seal interchangeably as the seals apparently carried the same legal authority.

SOPHIE CLUZAN

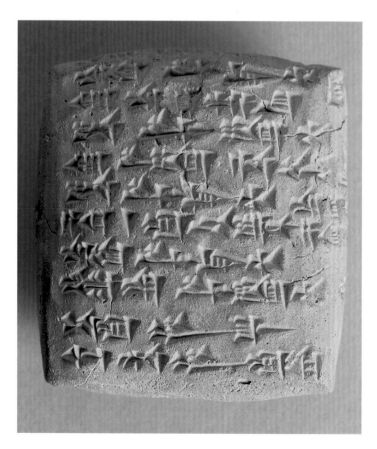

## 54
*Cylinder seal showing a battle between two griffons*

Ugarit, probably imported from Cyprus, ca. 1500–1375 BC
Green serpentine
⅞ × ½ inch (2.3 × 1.3 cm)
Excavations Schaeffer, 1933
Department of Near Eastern Antiquities, AO 17254

## 55
*Cylinder seal showing a banquet scene*

Ugarit, ca. 1500–1375 BC
Steatite
1 × ½ inch (2.5 × 1.3 cm)
Excavations Schaeffer, 1935
Department of Near Eastern Antiquities, AO 18548

## 56
*Cylinder seal showing a hunting scene*

Ugarit, ca. 1500–1375 BC
Stone
⅞ × ⅜ inch (2.3 × 1 cm)
Excavations Schaeffer, 1933
Department of Near Eastern Antiquities, AO 17243

## 57
*"Red lustrous wheel made ware" bottle*

Ugarit, late Bronze Age, middle of the 2nd millennium BC
Terracotta
11½ × 3½ inches (29.2 × 8.9 cm)
Excavations Schaeffer, 1936
Department of Near Eastern Antiquities, AO 19247

## 58
### *"Red lustrous wheel made ware" bottle*

Ugarit, late Bronze Age, middle of the 2nd millennium BC
Terracotta
12 × 2⅛ inches (30.5 × 5.3 cm)
Excavations Schaeffer, 1937
Department of Near Eastern Antiquities, AO 19187

## 59
### *"Red lustrous wheel made ware" three-handled lentoid gourd*

Ugarit, late Bronze Age, middle of the 2nd millennium BC
Terracotta
10¼ × 6⅞ inches (26 × 17.5 cm)
Excavations Schaeffer, 1935
Department of Near Eastern Antiquities, AO 32220

## 60

*"Bilbil" vase, imported from Cyprus*

Ugarit, late Bronze Age, middle of the 2nd millennium BC
Terracotta
4⅝ × 2 inches (11.7 × 5.1 cm)
Excavations Schaeffer, 1931
Department of Near Eastern Antiquities, AO 14953

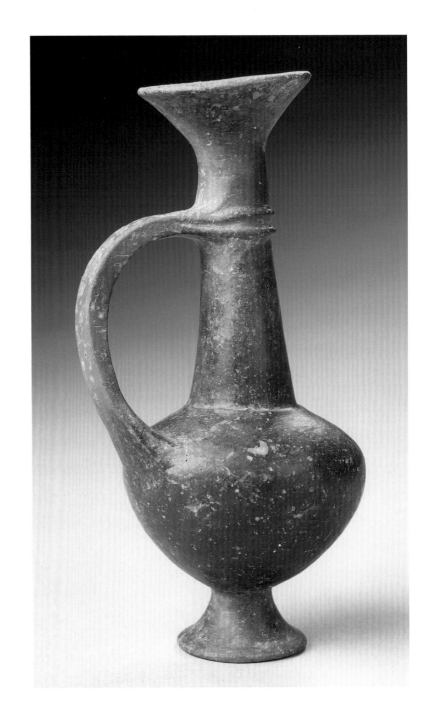

# 61

*"Milk Bowl" imported from Cyprus*

Ugarit, late Bronze Age, second half of 2nd millennium BC
Painted terracotta
3⅜ × 8¹⁄₁₆ inches (8.6 × 20.5 cm)
Excavations Schaeffer, 1936
Department of Near Eastern Antiquities, AO 19197

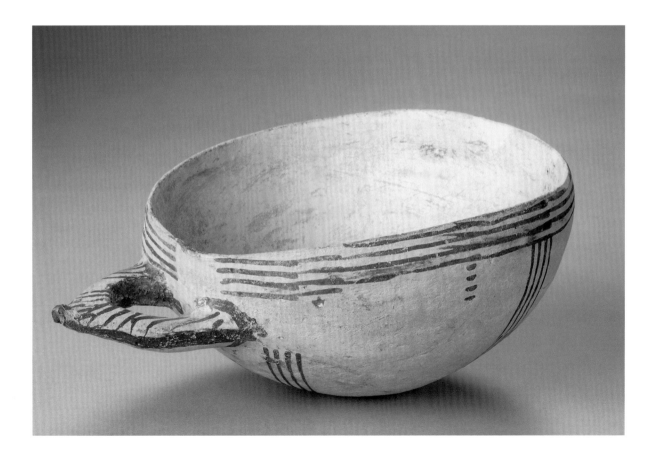

## 62

*Krater with chariots decoration, imported from Mycenae*

Ugarit, late Bronze Age, 14th–13th century BC
Terracotta
18⅞ × 15¾ inches (48 × 40 cm)
Excavations Schaeffer, 1936
Department of Near Eastern Antiquities, AO 20376

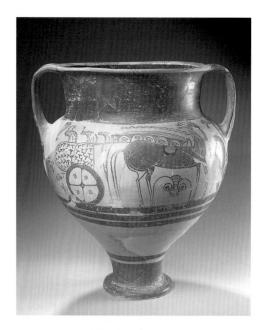

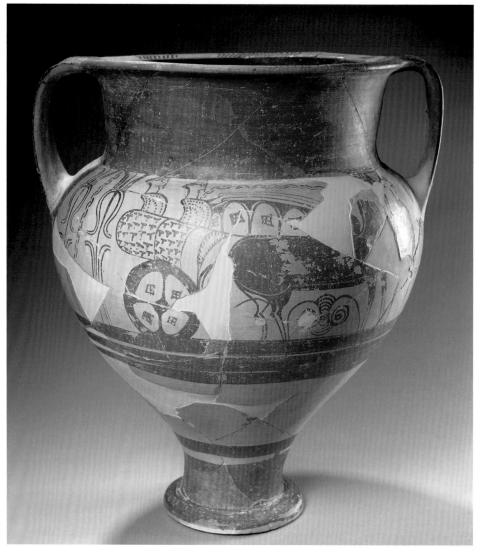

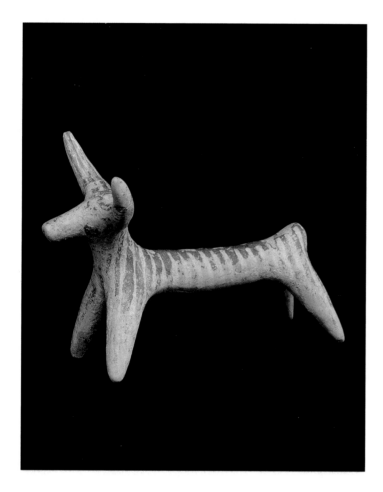

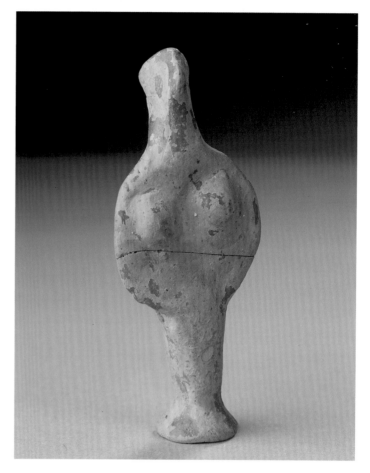

## 63
*Hand-modeled figurine of a bull, imported from Mycenae*

Ugarit, late Bronze Age, 14th–13th century BC
Painted terracotta
3⅛ × 4¼ × ⅛ inch (7.9 × 10.8 × 0.3 cm)
Excavations Schaeffer and Chenet, 1930
Department of Near Eastern Antiquities, AO 13129

## 64
*Female figurine shaped as a "phi" letter, imported from Mycenae*

Ugarit, late Bronze Age, 14th–13th century BC
Painted terracotta
2½ × 1 inch (6.4 × 2.5 cm)
Excavations Schaeffer and Chenet, 1931
Department of Near Eastern Antiquities, AO 14838

## 65
### *Adze of the Great Priest*

Ugarit, Late Bronze Age, 13th–12th century BC
Inscription engraved in alphabetical cuneiform script,
Ougaritic language
Bronze
9¼ × 2½ × 1⅞ inches (23.4 × 6.4 × 4.8 cm)
Excavations Schaeffer and Chenet, 1929
Department of Near Eastern Antiquities, AO 11610

This adze was found among weapons—some bearing an identical inscription—in an intentional depot, hidden under the threshold of a house within the Acropolis of Ugarit. The inscription reads "adze of the great priest," which made it possible to identify the building's owner.

Together with four other similar examples, this tool helped in the deciphering of the Ougaritic cuneiform alphabet of Ras Shamra by the Frenchman Charles Virolleaud and the German Hans Bauer. Virolleaud had suspected a possible parallel with an arrowhead from Sidon, inscribed in Phoenician, taking into consideration the assumption that Ras Shamra was located in the region of Phoenicia and that this language was likely spoken there. If the parallel held true, the first word would be the name of the tool and the second would be the owner, which turned out to be exactly the case. Separate deciphering tests were then carried out by Charles Virolleaud, Hans Bauer, and Edouard Dhorme of the French School of Jerusalem.

SOPHIE CLUZAN

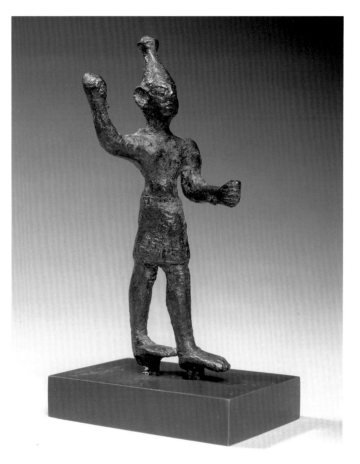

## 66

*Fragmentary alphabetic cuneiform tablet:*
*poem about the Prince of the Sea*

Ugarit, 14th–13th century BC
Baked clay
3⅜ × 2⅜ × 1½ inches (8.6 × 6.1 × 3.8 cm)
Excavations Schaeffer and Chenet, 1931
Department of Near Eastern Antiquities, AO 16643

## 67

*Figurine of the "fighting" god Baal*

Ugarit, late Bronze Age, 15th–14th century BC
Copper alloy (bronze)
3½ × 1¾ × 1½ inches (8.9 × 4.4 × 3.8 cm)
Excavations Schaeffer, 1937
Department of Near Eastern Antiquities, AO 19268

## 68

*Stele showing an astral symbol above an altar*

Ugarit, late Bronze Age, 14th–13th century BC
Sandstone
11⅞ × 5½ × 6½ inches (30.2 × 14 × 16.5 cm)
Excavations Schaeffer and Chenet, 1931
Department of Near Eastern Antiquities, AO 14919

## 69

*Bead necklace with figures of the goddess Ishtar and astral symbols*

Ugarit, late Bronze Age, ca. 14th–13th century BC
Carnelian, silver
7⅞ inches (20.1 cm) in diameter
Excavations Schaeffer, 1937
Department of Near Eastern Antiquities, AO 23999–24009

## 70

*Pendant representing a schematized naked goddess, Hathor*

Ugarit, late Bronze Age, 14th–13th century BC
Gold
1⅞ × 1 inch (4.8 × 2.5 cm)
Excavations Schaeffer and Chenet, 1931
Department of Near Eastern Antiquities, AO 14718

## 71

*Pendant with an astral symbol, probably Venus*

Ugarit, late Bronze Age, 14th–13th century BC
Gold
1 inch (2.5 cm) in diameter
Excavations Schaeffer and Chenet, 1934
Department of Near Eastern Antiquities, AO 17363

One tendency of ancient Near Eastern culture is seen in the absence of representations of the divine being. This aniconism has emerged at various periods in different areas. One current of thought considered that one could evoke the divine being with a simple upright stone (stele), with or without symbols. This practice seems to have been widespread in the second millennium, when the kingdom of Ugarit was at its most prosperous. A great number of stelae were set up within or near the temples of the respective cities of the region, according to a practice that would expand considerably throughout the first millennium—at the same time that the books of the Old Testament were being redacted. When confronted with this form of religious expression, Israelite priests opposed these practices and condemned the worship of these pillar stones, which they called *asheras*. They also bristled at representations of femininity, symbols of the important Near Eastern goddess Ishtar, or Astarte, who embodied the eternal feminine, tinged with the millennial power that characterized this major personality of the Near Eastern pantheons, closely associated with royal power and with the star Venus.

Ugarit did not practice astral divination. However, their representations prove the importance of the divine connection to the astral world. Present on certain stelae, but also on articles of jewelry such as this pendant and necklace, stars also were proscribed by the Bible, which considered them to be representations of divine entities. According to the book of Genesis, God assigned the stars their places, thus confirming the primacy of the god of Israel over the beloved stars of neighboring lands. The weight placed on the condemnation of idols—set forth in the second commandment—reflects how important these Ancient Near Eastern religions were to those asserting a new faith. And the discoveries from Ugarit show that these Biblical themes rest on a tangible reality of the Canaanite culture, sacrificing iconic or aniconic representations of the divine and its astral manifestations.

SOPHIE CLUZAN

69

68

70

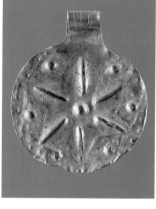

71

**37** *Molded figurine: naked woman with excessively large hips, supporting her breasts*
Susa, Middle Elamite period,
14th century BC
Terracotta
6⅜ × 3¾ × 2 inches
(16.3 × 9.5 × 5.1 cm)
Excavations R. de Mecquenem,
1928–1929
Department of Near Eastern
Antiquities, Sb 7797

**38** *Bull-man decoration from the dynastic temple of Susa*
Susa, Middle Elamite period,
Shutrukid Dynasty, reigns
of Kutir-Nahhunte and Shilhak-
Inshushinak, 12th century BC
Molded and baked clay bricks
54 × 14½ inches (137.2 × 36.8 cm)
(for each element)
Inscription in Elamite script
Excavations R. de Mecquenem,
1913–1921
Department of Near Eastern
Antiquities, Sb 21960

**39** *Archer decorating the royal palace of Darius the Great*
Susa, Achaemenid Persian period,
reign of Darius I (522–486 BC)
Apadana mound, Susa
Molded bricks with colored glazes
77⅛ × 31⅜ × 8⅞ inches
(195.8 × 80.3 × 22.6 cm)
Excavations R. de Mecquenem
Department of Near Eastern
Antiquities, Sb 23177

## TELLOH

**40** *Foundation peg inscribed with the name of Ur-Nanshe, King of Lagash*
Telloh, Mesopotamia, Early Dynastic
period III, reign of Ur-Nanshe,
ca. 2500 BC
Copper alloy (bronze)
4¼ × 1⅜ × 1 inch; 4½ × 2⅞ ×
2¾ inches (10.8 × 3.6 × 2.5 cm;
11.4 × 7.4 × 7 cm)
Excavations de Sarzec, 1881
Department of Near Eastern
Antiquities, AO 314

**41** *Foundation brick with the name of Ur-Nanshe, King of Lagash*
Telloh, Mesopotamia, Early Dynastic
period III, reign of Ur-Nanshe,
ca. 2500 BC
Gypseous alabaster
6⅞ × 4 × 2¾ inches
(17.5 × 10.2 × 7 cm)
Excavations de Sarzec, 1881
Department of Near Eastern
Antiquities, AO 253

**42** *Basket label with cylinder seal impression naming "En-ig-gal, scribe of the House of the princess"*
Telloh, Mesopotamia, Early Dynastic
period III, ca. 2400 BC
Clay
2½ × 2½ inches (6.4 × 6.4 cm)
Department of Near Eastern
Antiquities, AO 13223

**43** *Tablet listing cattle brought to the temple of the goddess Ba'u*
Telloh, Mesopotamia, Early Dynastic
period III, reign of Urukagina,
ca. 2400 BC
Clay
3 inches (7.6 cm) high
Department of Near Eastern
Antiquities, AO 13307

**44** *Statue of Prince Gudea in prayer*
Telloh, Mesopotamia, Neo-Sumerian
period, reign of Gudea, ca. 2120 BC
Dolerite
42⅛ × 14⅜ × 9⅞ inches
(106.9 × 36.6 × 25.1 cm)
Department of Near Eastern
Antiquities, AO 20164

**45** *Fragmentary tablet: myth of Lugal-e (the revolt of the stones)*
Telloh, Mesopotamia, Neo-
Babylonian copy, ca. 626–539 BC
Clay
2½ × 1½ × 1 inch
(6.4 × 3.8 × 2.5 cm)
Department of Near Eastern
Antiquities, AO 7748

**46** *Foundation peg representing a kneeling god, inscribed with the name of Gudea, Prince of Lagash*
Telloh, Mesopotamia, Neo-Sumerian
period, reign of Gudea, ca. 2120 BC
Copper alloy (bronze)
8½ × 1⅝ × 3 inches
(21.6 × 4.1 × 7.6 cm)
Excavations de Sarzec, 1881
Department of Near Eastern
Antiquities, AO 76

**47** *Human-headed bull*
Telloh, Mesopotamia, Neo-Sumerian
period, end of 3rd millennium BC
Black steatite
5¾ × 3⅛ inches (14.6 × 7.9 cm)
Department of Near Eastern
Antiquities, AO 2752

**48** *Male head*
Telloh, Mesopotamia, Neo-Sumerian
period, end of 3rd millennium BC
Black-green diorite
2½ × 1½ × 2 inches (6.4 × 3.8 ×
5.1 cm)
Excavations G. Cros, 1904
Department of Near Eastern
Antiquities, AO 4351

**49** *Sumerian religious text: The Passion of the God Lilu*
Telloh, Mesopotamia, beginning of
the 2nd millennium BC
Clay
4¾ × 2⅜ × 1¼ inches (12.1 × 6.1 ×
3.2 cm)
Department of Near Eastern
Antiquities, AO 3023

**50** *Molded plaque representing a female nude*
Telloh, Mesopotamia, early
2nd millennium BC
Terracotta
7 × 3 × 1 inch (17.8 × 7.6 × 2.5 cm)
Department of Near Eastern
Antiquities, AO 12205

**51** *Molded plaque representing a sitting goddess*
Telloh, Mesopotamia, beginning
of the 2nd millennium BC
Terracotta
4⅛ × 2 × ¾ inch
(10.4 × 5.1 × 1.9 cm)
Department of Near Eastern
Antiquities, AO 4593

**52** *Molded plaque representing a man carrying a kid*
Telloh, Mesopotamia, early
2nd millennium BC
Terracotta
4¾ × 2⅛ × ⅞ inch
(12.2 × 5.5 × 2.1 cm)
Department of Near Eastern
Antiquities, AO 16721

## UGARIT

**53** *Tablet bearing an Akkadian text and mark of the dynastic seal of the Kings of Ugarit*
Ugarit, late Bronze Age, reign of
King Niqmepa, 14th–13th century BC
Clay
2⅛ × 2 × 1 inches
(5.3 × 5.1 × 2.5 cm)
Excavations Schaeffer
Department of Near Eastern
Antiquities, AO 27987

**54** *Cylinder seal showing a battle between two griffons*
Ugarit, probably imported from
Cyprus, ca. 1500–1375 BC
Green serpentine
⅞ × ½ inch (2.3 × 1.3 cm)
Excavations Schaeffer, 1933
Department of Near Eastern
Antiquities, AO 17254

**55** *Cylinder seal showing a banquet scene*
Ugarit, ca. 1500–1375 BC
Steatite
1 × ½ inch (2.5 × 1.3 cm)
Excavations Schaeffer, 1935
Department of Near Eastern
Antiquities, AO 18548

**56** *Cylinder seal showing a hunting scene*
Ugarit, ca. 1500–1375 BC
Stone
⅞ × ⅜ inch (2.3 × 1 cm)
Excavations Schaeffer, 1933
Department of Near Eastern
Antiquities, AO 17243

**57** *"Red lustrous wheel made ware" bottle*
Ugarit, late Bronze Age, middle of
the 2nd millennium BC
Terracotta
11½ × 3½ inches (29.2 × 8.9 cm)
Excavations Schaeffer, 1936
Department of Near Eastern
Antiquities, AO 19247

**58** *"Red lustrous wheel made ware" bottle*
Ugarit, late Bronze Age, middle of
the 2nd millennium BC
Terracotta
12 × 2⅛ inches (30.5 × 5.3 cm)
Excavations Schaeffer, 1937
Department of Near Eastern
Antiquities, AO 19187

**59** *"Red lustrous wheel made ware" three-handled lentoid gourd*
Ugarit, late Bronze Age, middle of the 2nd millennium BC
Terracotta
10¼ × 6⅞ inches (26 × 17.5 cm)
Excavations Schaeffer, 1935
Department of Near Eastern Antiquities, AO 32220

**60** *"Bilbil" vase, imported from Cyprus*
Ugarit, late Bronze Age, middle of the 2nd millennium BC
Terracotta
4⅝ × 2 inches (11.7 × 5.1 cm)
Excavations Schaeffer, 1931
Department of Near Eastern Antiquities, AO 14953

**61** *"Milk Bowl" imported from Cyprus*
Ugarit, late Bronze Age, second half of 2nd millennium BC
Painted terracotta
3⅜ × 8¹/₁₆ inches (8.6 × 20.5 cm)
Excavations Schaeffer, 1936
Department of Near Eastern Antiquities, AO 19197

**62** *Krater with chariots decoration, imported from Mycenae*
Ugarit, late Bronze Age, 14th–13th century BC
Terracotta
18⅞ × 15¾ inches (48 × 40 cm)
Excavations Schaeffer, 1936
Department of Near Eastern Antiquities, AO 20376

**63** *Hand-modeled figurine of a bull, imported from Mycenae*
Ugarit, late Bronze Age, 14th–13th century BC
Painted terracotta
3⅛ × 4¼ × ⅛ inch (7.9 × 10.8 × 0.3 cm)
Excavations Schaeffer and Chenet, 1930
Department of Near Eastern Antiquities, AO 13129

**64** *Female figurine shaped as a "phi" letter, imported from Mycenae*
Ugarit, late Bronze Age, 14th–13th century BC
Painted terracotta
2½ × 1 inch (6.4 × 2.5 cm)
Excavations Schaeffer and Chenet, 1931
Department of Near Eastern Antiquities, AO 14838

**65** *Adze of the Great Priest*
Ugarit, late Bronze Age, 14th–13th century BC
Bronze
9¼ × 2½ × 1⅞ inches (23.4 × 6.4 × 4.8 cm)
Excavations Schaeffer and Chenet, 1929
Department of Near Eastern Antiquities, AO 11610

**66** *Fragmentary alphabetic cuneiform tablet: poem about the Prince of the Sea*
Ugarit, 14th–13th century BC
Baked clay
3⅜ × 2⅜ × 1½ inches (8.6 × 6.1 × 3.8 cm)
Excavations Schaeffer and Chenet, 1931
Department of Near Eastern Antiquities, AO 16643

**67** *Figurine of the "fighting" god Baal*
Ugarit, late Bronze Age, 15th–14th century BC
Copper alloy (bronze)
3½ × 1¾ × 1½ inches (8.9 × 4.4 × 3.8 cm)
Excavations Schaeffer, 1937
Department of Near Eastern Antiquities, AO 19268

**68** *Stele showing an astral symbol above an altar*
Ugarit, late Bronze Age, 14th–13th century BC
Sandstone
11⅞ × 5½ × 6½ inches (30.2 × 14 × 16.5 cm)
Excavations Schaeffer and Chenet, 1931
Department of Near Eastern Antiquities, AO 14919

**69** *Bead necklace with figures of the goddess Ishtar and astral symbols*
Ugarit, late Bronze Age, ca. 14th–13th century BC
Carnelian, silver
7⅞ inches (20.1 cm) in diameter
Excavations Schaeffer, 1937
Department of Near Eastern Antiquities, AO 23999–24009

**70** *Pendant representing a schematized naked goddess, Hathor*
Ugarit, late Bronze Age, 14th–13th century BC
Gold
1⅞ × 1 inch (4.8 × 2.5 cm)
Excavations Schaeffer and Chenet, 1931
Department of Near Eastern Antiquities, AO 14718

**71** *Pendant with an astral symbol, probably Venus*
Ugarit, late Bronze Age, 14th–13th century BC
Gold
1 inch (2.5 cm) in diameter
Excavations Schaeffer and Chenet, 1934
Department of Near Eastern Antiquities, AO 17363

## Nineteenth-Century Works

**Napoleon I**
Antoine Denis Chaudet (French, 1763–1810), 19th century
Marble
22 × 12⅝ × 11¹³/₁₆ inches (55.9 × 32 × 30 cm)
Department of Sculptures, MI 0040 (MNA 839120)
See page 11

**Bust of Jean-François Champollion**
Bonabes de Rougé (French), 1863
Marble
25⅛ × 13¾ inches (63.8 × 34.9 cm)
Department of Sculptures, RF 4637
See page 50

**Cambyses and Psammenitus**
Adrien Guignet (French, 1816–1854)
Oil on canvas
44⅞ × 83⅛ inches (1.1 × 2.1 m)
Department of Paintings, INV 5255
See page 52

## Notes on Contributors

**Béatrice André-Salvini** is head of the Department of Near Eastern Antiquities, an Assyriologist, and a specialist of Sumerian and Akkadian. She has participated in various archaeological excavations in the Middle East. As a curator she has been in charge of pre-Islamic inscriptions and Persian collections, as well as the relevant museographic programs. Among the exhibitions she has organized are *La naissance de l'écriture* (1982) and a series on "Writing" at the Bibliothèque nationale de France. She is currently preparing an exhibition on Babylon. Among her published works are *The Birth of Writing in Ancient Mesopotamia* (1992) and "Les tablettes du monde cuneiforme" (1992). She is the author of *Babylone* (2001) and *Babil* (2006) and a contributor to *Art of the First Cities: The Third Millennium B.C. from the Mediterranean to the Indus* (New York, 2003) and the exhibition catalogue *Forgotten Empire: The World of Ancient Persia* (London, 2005).

**Juliette Becq** has worked in the Department of Greek, Etruscan, and Roman Antiquities since 1997, when the collection of Greek terracotta figurines was re-installed. She helped organize the exhibition *Tanagra, Mythe et archéologie* (Musée du Louvre, 2003) and contributed to the Proceedings of the symposium *Tanagras, De l'objet de collection à l'objet archéologique,* edited by Violaine Jeammet (Musée du Louvre, 2007).

**Agnès Benoit** is a chief curator in the Department of Near Eastern Antiquities, where she has been in charge of the ancient Iranian collection since 1986. Her primary area of expertise lies in the relationship between the Elamite and trans-Elamite states of the 3rd millennium BC with Central Asia, when the wave of urban phenomena gave rise to the vast Oxus civilization, also known as the BMAC (Bactria and Margiana Archaeological Complex). She has also taught the history of the ancient Near East at l'Ecole du Louvre since 1994 and is the author of the textbook *Art et archéologie: les civilisations du Proche-Orient ancien,* published in 2003 and reissued in 2007. She holds degrees in Philosophy and in Literature.

**Geneviève Bresc-Bautier** became a curator in the Louvre's Department of Sculpture in 1976 and has directed the department as Chief Curator since 2004. Her areas of expertise include sixteenth- and seventeenth-century French sculpture (particularly the work of Jacques Sarazin), French bronze sculpture, and terracotta sculpture from the Maine region of France.

**Katerina Chatziefremidou** works with Etruscan art in the Department of Greek, Etruscan, and Roman Antiquities. She teaches at l'Ecole du Louvre in the areas of art history and Greek archaeology.

**Sophie Cluzan** is a curator in the Department of Near Eastern Antiquities, responsible for the Syrian, Cypriot, and Lebanese collections. After studying Near Eastern archaeology and written Arabic and participating in archaeological missions in Cyprus, Jordan, India, and Syria, she worked at the Arab World Institute, where she organized an exhibition on Syrian archaeology. After coming to the Louvre, she was assigned to the renovation of the National Museum of Beirut, then the founding of the Museum of Lebanese Prehistory at Saint-Joseph University in Beirut. She is currently working on the renovation of the National Museum of Damascus and is in charge of the Louvre's cooperative arrangement with Syria. She is the author of *Syrie, mémoire et civilization* (1993) and *De Sumer à Canaan: L'orient Ancien et la Bible* (2005).

**Françoise Demange** is a chief curator in the Department of Near Eastern Antiquities. She was at the Musée des Beaux Arts d'Orléans before coming to the Louvre in 1991. Responsible for the archaeological collections of Mesopotamia, she is also curator of antiquities associated with the Parthian Dynasty and the Sassanid Empire. She has curated several important exhibitions, including *Les Perses sassanides: Fastes d'un empire oublié (224–642)* in 2006 and *Glass, Gilding, and Grand Design: Art of Sassanian Iran* in 2007. Since 2005 Demange has headed a mission fostering scientific cooperation with the antiquities museums of Yemen.

**Sophie Descamps** is a chief curator in the Department of Greek, Etruscan, and Roman Antiquities, where since 1984 she has been in charge of the collection of bronzes. She is working on northern Greece and is the editor of the Proceedings of the symposium *Couleur et Peinture dans le monde grec antique* held at the Louvre (2007). She teaches at l'Ecole du Louvre.

**Marc Etienne** has been a curator at the Louvre since 1992 and the curator of the papyri section of the Department of Egyptian Antiquities since 1995. He is a specialist in Egyptian religion, notably the cult of Osiris and studies of magical spells. He contributed to the catalogues *Pharaohs of the Sun: Akhenaten, Nefertiti, & Tutankhamen* (Museum of Fine Arts, Boston, 1999), *Cleopatra of Egypt: From History to Myth* (British Museum, 2000), and *La mort n'est pas une fin. Pratiques funéraires en Egypte d'Alexandre à Cléopâtre* (Musée de l'Arles antique, 2002). He has participated in excavations in France and Egypt since 1985, including such sites as the Valley of the Queens in Luxor, the Temple of Montu in El Toud, and the tomb of Akhethetep in Sakkara.

**Ludovic Laugier** specializes in Greek sculpture in the Department of Greek, Etruscan, and Roman Antiquities and teaches at l'Ecole du Louvre. He is the author of the *Catalogue raisonné des Antiques du Musée Condé à Chantilly* and contributed to the volume *Les Antiques du Louvre, une histoire du goût de Henri IV à Napoléon Ier*.

**Alain Pasquier** is head of the Department of Greek, Etruscan, and Roman Antiquities. He is the author of a number of publications on Greek art, notably *La Vénus de Milo et les Aphrodites du Louvre* (1985), *L'Art grec* (1998, with Bernard Holtzmann), and *Praxitéle* (2007, with Jean-Luc Martinez). He has published many scholarly articles in all areas of ancient art—bronzes, terracotta figurines, vases, and sculpture. He was one of the organizers of the Louvre exhibition *Deux Mille Ans de creation . . . d'après l'antique* (2000).

**Sophie Padel-Imbaud** works with ancient Greek ceramics in the Department of Greek, Etruscan, and Roman Antiquities. She has worked at the Louvre since 1994 and is the author of *Jeux olympiques et sport dans la Grèce antique* (2004) and *L'Idéal athlétique: image du corps dans les vases grecs* (2004).

**Daniel Roger** has been a curator in the Department of Greek, Etruscan, and Roman Antiquities since 2003, where he specializes in Roman marbles, paintings, terracottas, and ceramics. He began his career teaching French, Latin, and Greek literature, then became a government archaeologist, organizing rescue excavations on the future sites of industrial parks and highways. In 1998 he was in charge of the huge archaeological field on the site of a Toyota plant. He has also led excavations at Famars, a small city in northern France that has remarkable Roman wall paintings.

**Christiane Ziegler** is former head of the Department of Egyptian Antiquities. She has organized such major exhibitions as *Egyptomania* (1994), *L'art égyptien au temps des pyramides* (1999), and *les Pharaons* (2002), and is the author of *Louvre Antiquities* (1994), *Les Pyramides d'Egypte* (1999, with Jean-Pierre Adam), *The Pharaohs* (2002), and *Le Mastaba d'Akhethetep* (2007).

# Index

Boldfaced titles indicate exhibition works. Boldfaced page numbers indicate color plates. Italicized page references indicate illustrations. Maps are indicated with "m" italicized following the page number.

Published on the occasion of the exhibition *The Louvre and the Ancient World,* organized by the High Museum of Art, Atlanta, and the Musée du Louvre, Paris.

# LOUVRE ATLANTA

High Museum of Art
October 16, 2007–September 7, 2008

Library of Congress Cataloging-in-Publication Data
    The Louvre and the ancient world : Greek, Etruscan, Roman, Egyptian, and Near Eastern antiquities from the Musée du Louvre.
       p. cm.
    Includes bibliographical references and index.
    ISBN-13: 978-1-932543-19-3 (hardcover : alk. paper)
       1. Art, Ancient—Mediterranean Region—Exhibitions. 2. Mediterranean Region—Antiquities—Exhibitions. 3. Art—France—Paris—Exhibitions.
    4. Musée du Louvre—Exhibitions. I. High Museum of Art.
    N5336.F8P35 2007
    709.3'07444361—dc22                                        2007029502

*Details*
p. 2: *Crouching Aphrodite,* Roman (cat. 7)
p. 5: *Human-headed bull,* Telloh, end of 3rd millennium BC (cat. 47)
p. 8: Hubert Robert, *The Grand Gallery of the Louvre,* 1796 (fig. 7, p. 13)
p. 20:. *Funerary stele of Philis,* Greek, ca. 450 BC (cat. 5)
p. 48: *Fragment of a royal decree,* Egypt, 264–263 BC (cat. 24)
p. 76: *Statue of Prince Gudea in prayer,* Telloh, ca. 2120 BC (cat. 44)

For the High Museum of Art
Kelly Morris, Editor
Heather Medlock, Assistant Editor
Rachel Bohan, Editorial Assistant
Translation by Michael Hariton
Additional translation by Janice Abbott (pp. 9–29; cats. 8, 9)

Designed by Jeff Wincapaw
Color separations by iocolor, Seattle
Produced by Marquand Books, Inc., Seattle
   www.marquand.com
Printed in the United Kingdom by Butler and Tanner

**Photo Credits**
*Plates*
Peter Harholdt by permission of the Musée du Louvre, Paris / High Museum of Art, Atlanta: cats. 1, 3, 4, 7, 8, 11, 15, 18, 20, 21, 23–25, 27, 28, 30–32, 35, 36, 41–46, 50–62, 64–68.
© Réunion des Musées Nationaux / Art Resource, NY: cats. 2, 5, 6, 9, 10, 12–14, 16, 17, 19, 22, 26, 29, 33, 34, 37–40, 47–49, 63, 69–71.

*Figure Illustrations*
© Réunion des Musées Nationaux / Art Resource, NY: Bresc figs. 1–4, 7, 8, 10, 11, 13; Cluzan figs. 3, 4; Pasquier figs. 1–7, 9, 12–16; Ziegler figs. 2–4, 6, 7, 10, 11; André-Salvini figs. 4, 6–8, 10; Benoit figs. 2, 4–8; Demange figs. 2, 4, 6–8.
© Musée du Louvre / Etienne Revault: Pasquier figs. 8, 10.
© Musée du Louvre / Pierre Ballif: Pasquier fig. 11.
© HIP / Art Resource, NY: Ziegler fig. 1.
© Erich Lessing / Art Resource, NY: Ziegler fig. 5; André-Salvini figs. 3, 5.
© Giraudon / Art Resource, NY: Ziegler fig. 8; André-Salvini fig. 2.
© Musée du Louvre / Christian Décamps: Ziegler fig. 9.